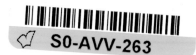

THEODORE WORES
IN THE SOUTHWEST

EDITED BY STEPHEN BECKER

Dedicated to the memory of A. Jess Shenson

Cover Art: Colorado Historical Society
 Painter at Pueblo, Taos, October 10, 1917, Fred Payne Clatworthy, photographer, Lumiere Autochrome on glass Courtesy Colorado Historical Society, 10031218

Cover Design: M. Kathleen Kelly, Katz Graphics
Interior Design/Typesetting: M. Kathleen Kelly, Katz Graphics

Printing and Binding: Hemlock Printers Ltd.

Distributed by Heyday Books

Orders, inquiries, and correspondence should be addressed to:
Heyday Books
P.O. Box 9145, Berkeley, CA 94709
(510) 549-3564, Fax (510) 549-1889
www.heydaybooks.com

Printed in Canada

10 9 8 7 6 5 4 3 2 1

ISBN 1-59714-047-3

THEODORE WORES
IN THE SOUTHWEST

EDITED BY STEPHEN BECKER

CALIFORNIA HISTORICAL SOCIETY, SAN FRANCISCO, CALIFORNIA

HEYDAY BOOKS, BERKELEY, CALIFORNIA

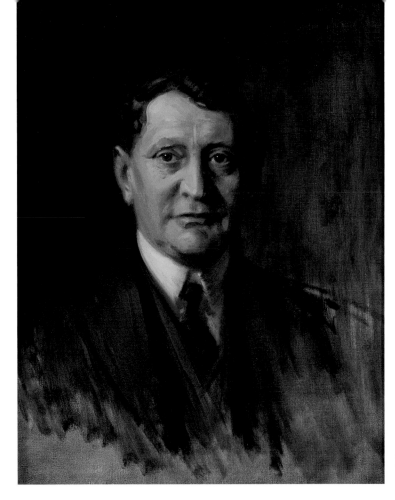

Portrait of Theodore Wores
1915
Herman Herkomer
oil on canvas
Courtesy of Fred M. and
Nancy Livingston Levin

Theodore Wores in the Southwest

Introduction

High atop Nob Hill, hidden from view in the basement ballroom of a regal apartment house, a painter's widow quietly kept a private display of her late husband's paintings. She had hung them there a long time ago, this collection that she lovingly maintained in memory of her husband who died in 1939. Almost no one knew the paintings were there. Among the artworks was a large, full figure oil portrait of a young woman in a flowing gown. "It was my first long dress," she remembered, years later. "It was blue *peau de soie* trimmed in sequins. It was beautiful."[1]

Caroline Bauer was a diminutive 17-year-old San Franciscan when Theodore Wores painted her portrait, and the elegant gentleman artist must have struck her as handsome and worldly. Many years her senior, Wores was at the top of his artistic and professional game. Born in San Francisco, he had traveled the world. He was among the first artists to live and work in Japan; he visited Spain to paint at the Alhambra; and he spent time in the exotic Hawaiian Islands and Samoa to paint portraits of native peoples of the Pacific. He was a precocious child who became

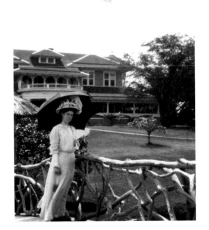

Carolyn Bauer Wores
c. 1910
Theodore Wores
Courtesy of Fred M. Levin

one of the first students at the San Francisco Art Institute, where his talents were revealed. He was offered a chance to study in Europe, which he accepted, and where he perfected his style of picturesque realism. His studies were enriched by working alongside students who became stars in the art world. He knew Whistler, Keith, Rix and Tavernier. He eventually returned to his native city and became the first director of the San Francisco Institute of Art, and he is often credited with the vision that led to the creation of the de Young Museum after the 1894 California Midwinter International Exposition in Golden Gate Park. A year after Wores painted Caroline's portrait, they married.

Nearly 110 years after that fair, on a typically crisp and glorious October day in Taos, New Mexico, we gathered – a small group of historians, ethnologists, curators, art historians, and artists. We came from many backgrounds: members of the Taos and other Pueblos born and raised in the high desert country; city folk from both coasts; and long-time immigrants to the Southwest, the travelers and seekers who always seem attracted to the mesas, forests and canyons of New Mexico. Certainly we all agreed about one thing: this country beckons you, and whether it was a first trip to the High Southwest or you lived nearby surrounded by chamisa and piñon, one easily could see the attraction of this place. No one with a lust for travel and an interest in compelling places could skip coming here. Once visited, the place lures you back time and again.

We came together to consider the paintings of Theodore Wores, a painter born in San Francisco in 1859, just as the frenetic bustle of the Gold Rush years was calming down, and the wealth of the mines was fueling the transformation of San Francisco into the Paris of the West. The young Wores benefited from the nascent sophistication of the city. His parents raised and educated him to become an artist – the first from San Francisco, it is said, to gain professional, European training. But it was Wores' interests in the exotic and in world travel that led to his greatest achievements in art.

After training at the Royal Academy in Munich, Wores returned to San Francisco where he painted scenes of the Chinese and their Chinatown neighborhood and where he took on Chinese students to train them in European style painting – also a first. Remembering his talks with the artist James Whistler during his days in Europe, he set out for Japan in 1885 and again in 1891. In Japan he created his greatest paintings – the subjects were Japanese hamlets and villages, especially scenes of traditional life, almost always painted with a bright, colorful palette with flowers everywhere.

Paintings from Wores' travels in search of "the picturesque"[2] became his stock in trade. He sojourned in Hawaii and Samoa, and to the north of America to Calgary,

always painting native peoples, compelled to record through his paintbrushes, almost like an ethnologist, painting peoples popularly believed to be vanishing civilizations.

During our several days together, our group[3] inspected photographs of a collection of Wores' paintings of Southwest Indians that he painted in 1915, 1916 and 1917. He made many of the works in Taos, and they were mostly portraits and scenes of Taos Pueblo men, women and children, along with a few landscapes of the old Pueblo and Taos Mountain beyond. From letters Wores wrote to his wife in 1917, we knew a few important bits about the people in the Taos paintings. The collection of letters were saved by Mrs. Wores and passed on to family friends. Tucked away through all those years, they now served as a fine record of almost every day's activities. In one letter, he wrote the name of his guide, his helper, and his model for many of the paintings: Ralph Martinez, whom Wores called "my Indian."

A curious collection, some 50 in number, Wores' paintings of Southwestern Indians were given by his widow to the Natural History Museum of Los Angeles County, where they had not been seen or much used in the intervening years. It was quite possible that the reason for this lack of use and public interest was that these paintings did not always display his best work. In fact, only a few reach the artistry and magnificence of his masterworks from his youthful years in Japan. Wores was 58 years old in 1917, 26 years older than he was at the time of his first visit to Japan. However, while some seem clumsy and others pleasant and gentle, they hold particular meaning as a record of a time past. In addition, they are important in this story of how an artist saw an "exotic" people and how the artist and his subjects interacted. In this way, these works have another story to tell: the story of a relationship between native peoples and artists. And finally, these artworks are an archive of people, an unexpected family album, separated by cultures, distance and time from the descendants of those whose likenesses are rendered on these canvases.

When we started to discuss these paintings, we found ourselves asking questions regarding their significance and meaning. What makes a painting important? Is it the artistry alone or the subject matter? Tony Abeyta, a young and phenomenally successful Native American artist who was part of our group, said that he would be proud to have in his home even the most modest of these paintings. Tony was grateful that the artist had spent enough time with a fondly remembered tribal member to permanently record their presence. Tony remarked: "I would be honored to have that painting on the wall in my home."

The brothers Ben and Jess Shenson, both Stanford trained medical doctors, met the artist Theodore Wores while growing up in San Francisco. Their mother, Rose, was a good friend of Wores' wife, Carolyn. But it wasn't until many years later that Ben

and Jess became Wores collectors and enthusiastic advocates for the rediscovery of Wores' art. Sometime in the late 1960s, during a visit with Mrs. Wores, she agreed to show them her collection of the artist's works. They remembered the moment they first viewed the collection, which had been moved to the third floor of the Marines Memorial Building.

> *The long narrow gallery was in total darkness when all the lights were turned on with the flip of a switch. Suddenly, a burst of color flooded the room in every direction. Our friend [who accompanied them] turned to Mrs. Wores and said, 'Do you realize what you have locked up behind these doors?' Nearly a hundred Theodore Wores paintings lined the walls in her gallery...and at that moment it appeared as if each one took on a new, vibrant look. That was in 1967 and marked the beginning of the resurrection of the art of Theodore Wores.* [4]

This book and the exhibition that it complements are dedicated to Rose, Jess and Ben Shenson. Their passion for Theodore Wores' work led them to become prolific collectors. After the death of their mother, Rose, the Shenson brothers continued to live in their family home and practice medicine. They contributed generously to civic and arts organizations including the California Historical Society, San Francisco Symphony, Stanford University, St. Francis Hospital, and the San Francisco Opera, to name only a very few. In 2002, Jess Shenson's endless passion for Wores' work inspired him to conceive this exhibition and book and to make a generous gift to make them happen. It was just weeks before his death. It is a testament to Jess Shenson's incredible joy, sparkling eyes, and encouraging enthusiasm that he wanted this project not to be a memorial to himself as a collector but to be a lasting tribute to the artist he so admired. Dr. Shenson long felt that the collection of portraits and landscapes of Native Americans that Mrs. Wores donated to the Natural History Museum of Los Angeles County suffered from lack of recognition and display. Having lived and worked for ten years in Santa Fe as director of the Museum of New Mexico's Museum of Indian Arts and Culture, I was eager to try my hand at investigating and exploring these paintings. Dr. Shenson agreed to my proposal, and generously provided a gift to the California Historical Society that allowed for extensive research and planning for this book and exhibition.

Dr. A. Jess Shenson passed away in February 2002; I never had the opportunity to meet his brother, Dr. Ben Shenson, who died in 1995. The drive and excitement about the brothers' passion for Theodore Wores' work has passed to their cousin Fred Levin, to whom I owe tremendous gratitude for his encouragement, patience and assistance throughout this project. Fred dove into his cousins' Wores archive on our behalf, for the Shensons' passion for the artist was a thorough one, and they collected more than just paintings. When Mrs. Wores died, the Shensons acquired

numerous writings, notes, and photographs by Wores, and a considerable collection of news clippings, books, catalogs and archival materials. It was Fred's sleuthing that produced perhaps the most amazing rediscovery for this project – over 200 black and white photographs taken by Wores in 1915, 1916 and 1917 – a wonderfully amazing key to understanding Wores' work in the Southwest. These photographs show Wores' dedication to the camera as a painter's tool. His photographs are a tremendously rich record through which we were able to learn even more about the Native Americans from Navajo and Pueblo country who posed for his paintings.

Our thanks, then, go to the Shenson brothers, and to Fred Levin, for their dedication and energy, foresight and passion.

My acknowledgements would not be complete without thanks to Pamela Young Lee, former Chief Curator of the Society, and Paula Rivera, project researcher. Pam and Paula investigated Wores' paintings, and it was through their research that the project took the turn I had hoped for, leading us to many of the names, stories and personalities of the Native American models depicted in the portraits. This book and exhibition are also dedicated to Paula and her family at Taos Pueblo, who welcomed us with enthusiasm and great interest. Most especially, I also thank and dedicate this book to Mr. Lorenzo Alfred Lujan, Paula's grandfather, whose insight, knowledge and generous willingness to share his family's and community's history with us led us to discover the families and people Wores painted, creating a dynamic, new understanding of these works from both sides of the canvas – Wores as painter and his Native American subjects as representatives of their communities.

STEPHEN BECKER
SAN FRANCISCO
JUNE 2006

1 *California Living Magazine, San Francisco Chronicle*, November 12, 1967.

2 Lewis Ferbaché, *Theodore Wores: Artist in Search of the Picturesque*, 1968.

3 Attendees at the Taos Wores workshop are listed in the acknowledgements.

4 *California Living Magazine, The Sunday San Francisco Examiner and Chronicle*, November 12, 1967.

Ethnography in Art

STEPHEN BECKER

By the time that the young Theodore Wores set out for Japan in 1885, he had achieved acclaim for painting "exotic" scenes in his hometown of San Francisco. Wores' paintings of San Francisco's Chinatown, a neighborhood that had intrigued him since his boyhood, had been extremely successful and met with local critical approval. The painter's considerable formal training in Germany, thoroughly documented in Lewis Ferbaché's *Theodore Wores: Artist in Search of the Picturesque*, had provided Wores a way to see his works as part of a new storytelling painting style. He was telling visual stories of everyday life among Chinatown's shops and alleyways, restaurants and streetscapes, with Chinese residents dressed in exotic costume. Local art critics enamored of the young man's Chinese series heralded this as "fresh and picturesque."

In Japan Wores would truly bring together his passion for travel to foreign locales and his love of painting in far away places. While there, he produced paintings that when brought home to the United States were applauded as groundbreaking. Wores' timing combined with his excellent negotiating skills and good fortune afforded him time to study and live among the upper classes of Japanese society before many other artists had the same opportunity. In turn, Wores' series of Japanese paintings became his earliest major success. As reported in the New York *Daily Tribune*, on April 23, 1888:

> *The paintings of Japanese subjects, exhibited by Mr. Theodore Wores at the Reichard Gallery, will be found a valuable product of "ethnography in art," which...has developed only within [the] present century. They are valuable, not merely from their pictorial interest, but because it is true, with obvious reservations...that a view of an unknown country, executed by a sympathetic artists, will give us more of a knowledge of it that any number of photographs or geographical and descriptive treatises.*

Traveling and painting in Asia and the Pacific Islands became Wores' life and passion. He traveled to Hawaii, Samoa and back to Japan in the last decades of the 19th century. When he returned to San Francisco, he continued to paint Chinese subjects. His Japan trips were certainly an ethnographic adventure. He had the time to visit many towns and villages as well as the great cities of Japan, but more importantly he followed the early ethnographer's practice of living among the people, learning their language, customs and folkways, and translating what he learned to sketches and paintings. Although much discussed and desired, such lengthy visits to far-off places were still rare among American and European artists.

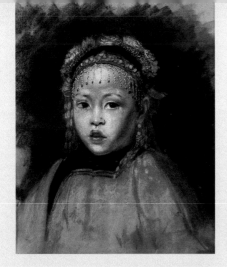

China Girl in Headdress
n.d.
Theodore Wores
pastel on paper
Courtesy of Fred M. and
Nancy Livingston Levin

Theodore Wores established his unique painting style very early in his career. First schooled in art in San Francisco, Wores traveled as a young man to study under Frank Duvenek, one of the most influential expatriate American artists of the 19th century. Wores became one of the "Duvenek Boys," a group of students who followed the master realist artist to study in Germany. Duvenek's influence led to Wores' strength in painting portraits, but it was Wores' interest in what were regarded as exotic peoples that built his success and reputation. "China Girl in Headdress" and "A Daughter of Seville" are examples of portraits that best reflect Duvenek's influence, displaying finely painted heads in front of indistinct, partially "unfinished" dark backgrounds. Wores' work in Japan and the Pacific islands, however, firmly established his interests in women as models and floral scenes, often coupling images of women at work with gardens, as in "Iris Garden, Hori-Kiri, Tokyo" or involved in a refined traditional activities, as with "The Matt Maker" and "The Samisen Player I" and "The Samisen Player II." In "The Street Entertainer," Wores shows that his style can also be more roughly drawn, capturing a moment of ethnographic interest. Each of these paintings have their counterparts among those Wores later made in the Southwest, repeating many similar poses and themes, and drawing again upon his most successful style, paintings that set his female models in fields and gardens full of flowers.

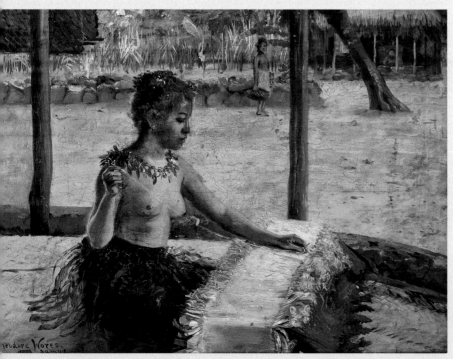

The Matt Maker
n.d.
Theodore Wores
oil on board
Courtesy of Fred M. and Nancy Livingston Levin

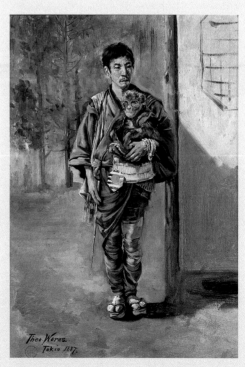

The Street Entertainer
1887
Theodore Wores
oil on canvas
Courtesy of Fred M. and Nancy Livingston Levin

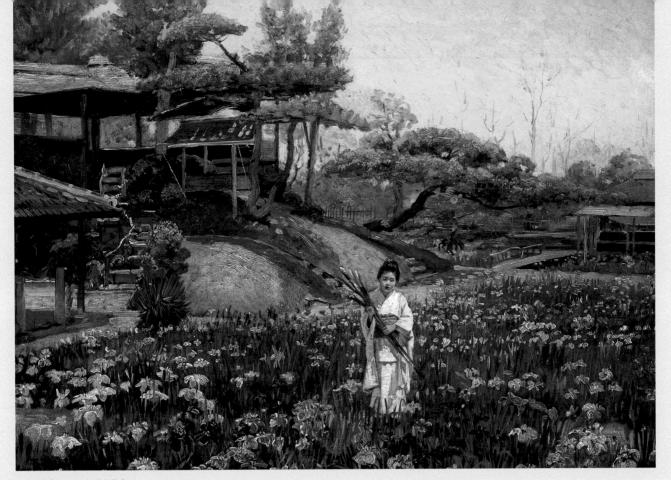

Iris Garden, Hori-Kiri, Tokyo
n.d. (c. 1895)
Theodore Wores
oil on canvas
Courtesy of Fred M. and Nancy Livingston Levin

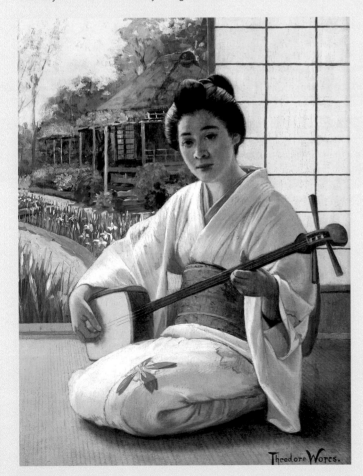

The Samisen Player II
1887
Theodore Wores
oil on board
Courtesy of Fred M. and Nancy Livingston Levin

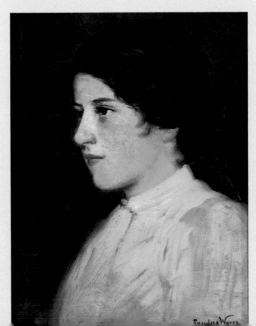

The Samisen Player I
n.d.
Theodore Wores
oil on board
Courtesy of Fred M. and Nancy Livingston Levin

A Daughter of Seville
1903
Theodore Wores
oil on board
Courtesy of Fred M. and Nancy Livingston Levin

Wores' trips to Japan were a direct result of encouragement from accomplished artist James Abbott McNeill Whistler. Whistler saw great promise for an artist who could travel to Japan, something he himself hoped to do and very few others had yet to accomplish.

Wores' work in Japan and the Pacific has been detailed and documented in a number of books and exhibit catalogs and pamphlets. However, it is worth noting that the artist's travels resulted in his permanent attraction to painting "ethnographic portraits," a mainstay of his art production with his floral scenes and California landscapes.

After the 1906 earthquake in San Francisco (Wores was in Los Angeles at the time of the destructive earthquake and fires), Wores was appointed dean of the faculty of the San Francisco Art Association's School of Design that was affiliated with the University of California. For the next seven years, Wores stuck close to home. He married young Carolyn Bauer in 1910 (he had painted her portrait the year before), and concentrated on his administrative duties while beginning a series of "sand dune" paintings of ocean scenes around the Bay Area. By 1913 Wores returned briefly to painting exotic subjects, traveling to the Canadian Rockies where he was inspired to paint the monumental "Hunting Grounds of the Past," depicting a Plains Indian gazing sadly yet stoically upon a city rising from the plains below. In Calgary he recorded parades and street fairs with his now ever-present camera, foreshadowing his next sojourn and body of work: a three-year return to painting native peoples in their villages and homes, exactly as he had done in Japan and the Pacific – but with a most interesting twist.

TOURISM IN THE SOUTHWEST

As noted in Bruce Bernstein's impressive study on the effects of early tourism and marketing on Southwestern Indian pottery,[1] displays of Southwestern Indian peoples and their arts were major attractions at World's Fairs from Chicago in 1893, Omaha in 1898, Buffalo in 1901, St. Louis in 1904, and San Francisco and San Diego in 1915. All of these exhibitions and displays of living people had two significant outcomes. They encouraged the ongoing serious scholarship of native peoples in the new departments of anthropology and ethnology in universities and museums throughout the country. On the other end of the cultural spectrum, far from the halls of academe, these exhibitions cooperated with regional tourism forces such as the Santa Fe Railroad (and it's *Sunset Magazine*) and the Harvey House hotels along the Southwestern rail routes. The trains brought carloads of exploring tourists for the first time to these desert lands, and the Harvey House hotels and tours accommodated the lucrative trade. Over time, the number of tourists to the Southwest grew, increasing the visits and tours among the Indian

tribes and pueblos, and encouraging a kind of cultural voyeurism never before seen in such large numbers in the United States.

Bernstein recounts that the Santa Fe Railroad's "Indian Campaign" to leverage tourist interest in Indian Country began in 1900 when the railroad began to collect paintings of the American West for décor in rail stations, offices, and for use in promotional literature. As opposed to the portrayal of "fierce" and "warlike" Indians such as the Apache, the Pueblo peoples of the Southwest were portrayed as "sober, sage artisans; residents, from time immemorial, of neat adobe towns – the continent's first and most ancient tribes." Indeed, the display of Pueblo peoples at many of the fairs and eventually in the Harvey House gift shops, contrasted sharply with the treatment of the old Apache warrior Geronimo, who was trotted out at fair after fair to sign autographs and to be exhibited and photographed as a vanquished and conquered leader.

By the time Wores began his series of paintings of Southwestern Indians in 1915, the reproduction of Native American environments and faux architecture was in full swing. Architect Mary Colter was the Santa Fe Railroad's and Harvey Company's leading designer of the spaces and places where indigenous arts and crafts were sold and displayed. The artisans worked alongside the displays, creating their handicrafts and posing for photographs taken by the tourist hordes. The transformation of Native American craft into a commodity with mass appeal and the effects that brought to the craftspeople is well documented in Bernstein's dissertation and later writings. It was the ongoing influence of the railroad's promotions to bring increasing numbers of travelers to see the "Real Southwest" that led to the creation of the Grand Canyon exhibit at the Panama Pacific International Exposition in San Francisco in 1915, and the even more elaborate and creative "Painted Desert" exhibition at the competing Panama-California Exposition in San Diego.

It was at the San Francisco exhibit, a tourist-trap affair in the "Fun Zone" of the PPIE, that Wores was inspired to launch his Southwestern Indian series that occupied him for the next three years. In front of his camera he posed Pueblo, Navajo and Hopi artisans and their families who were part of the display at the PPIE, and used the photos to create paintings with titles that belie the true setting in which the images were captured – a simulated Indian village atop the Grand Canyon exhibit. Indeed, some writers have assumed from the titles of Wores' paintings that he traveled in 1915 to the places he depicted. Through careful research for this project, it is now known that Wores' work in this series first took place in the San Francisco PPIE, or, more likely, at his home studio with the benefit of his numerous photographs.

Wores changed from the early painter-ethnographer to a tourist-ethnographer, first indulging his passion for painting exotic subjects at the PPIE. When he took the

next step and traveled to the Grand Canyon in 1916, he continued to paint Native peoples in Mary Colter's imitative architectural space. But by 1917, Wores returned, however briefly, to the methods he used in Japan and the Pacific when he traveled to the genuine source – to Taos.

WORES AND THE CAMERA

Without a doubt, it was the discovery of more than 200 photographs taken by Wores from 1915 through 1917 that made this project all the more intriguing. Known as a plein air painter, Wores' love of the camera as a tool for his art is demonstrated by the collection of his photographs from this time, including many that are nearly precise duplicates of Wores' canvases. In addition, there are a number that provided Wores with a kit bag of parts for assembling paintings later in his studio. In his seminal work *The Painter and the Photograph – from Delacroix to Warhol,*[2] Van Deren Coke provides evidence that painters used cameras to assist them since at least the early 1850s. By the turn of the century, cameras were prevalent, roll film made them easy to use, and one no longer had to be a chemist and proficient in the dark room to take photographs. Painters such as Thomas Eakins, Paul Gaugin, Paul Cézanne, Edvard Munch and numerous others adopted the camera as a tool seemingly as soon as the technology was available to them, and Wores was no different. Among the many photographs, it is interesting to note how rarely he took informal snapshots – Taos Pueblo's San Geronimo feast day, a few photographs of the new Museum of Fine Arts under construction in Santa Fe, and a few of family and friends count among the few snapshots found in the Wores collections of the Shenson family. Wores was not alone in using photography as an aid to painting Native Americans in Taos. Among the Taos artists, Irving Couse used photography for some of his most complicated images of Native American ceremonies and dance, including photographs he made at Hopi in 1903. As Van Deren Coke has proven, Oscar Berninghouse, another Taos artist, was known to use historic photographs as well, relying on photographs made in the 1890s by others for backgrounds in his paintings made a quarter of a century later.

In his Southwestern Indian series, there are many instances when Wores' photography outperforms the aging artist's dexterity with brush and canvas. His ability to frame in the camera a photograph of his posed models is, in fact, quite remarkable. All the photographs in this book are printed full frame, a demonstration of the artist's strong ability to see and sense how he wanted his canvases to appear in final form.

While Wores' prolific use of photography provides an insightful record of his visual thinking, it also provides an intriguing record, rarely seen, of how numerous painters of Native American subjects worked with their models. Wores' letters, of course, show that not only was the daily or hourly rate paid to models quite meager,

but also the work of modeling was hard, especially in Wores' case, as he preferred to work outdoors. Wores and his models both worked under a hot sun out in the Taos high desert; what a pleasure it must have been to work instead at the PPIE in San Francisco's fog-cooled climate. Along with his models, Wores, dressed in suit and tie, suffered the high desert heat; he noted in his letters how the sun burned him, and how he and his models in Taos often had to find ways to adjust to the bright sun.

The photographs also provide a record of some of the Native Americans who traveled to San Francisco to participate in the PPIE. Further research is needed to find the identities of those who worked at the faux Indian village in San Francisco in 1915. That work will probably require combing the records and logs of Indian Agents who likely would have "signed out" those who traveled off the reservation lands to work at the fair. This could be a tremendously tedious process, and it is hoped that the publication of Wores' photographs and paintings might refresh memories in Navajo, Pueblo and Hopi communities about the adventurous 1915 trip to San Francisco made by community members, some of whom were very young children and may still be alive. Field research among selected tribes did not deliver any direct results; both Paula Rivera and the author brought photographs and copies of the paintings to numerous elders in communities from which the PPIE participants came. One such trip resulted in a wonderful afternoon spent with elders at the Isleta Pueblo Elder Center, just south of Albuquerque. There was a lively discussion about participation of the now senior generation's parents and grandparents who worked in the tourist trade at the Alvarado Hotel in Albuquerque, and how fascinating it must have been for some of them to travel to San Francisco, a place just as exotic to Pueblo Indians at that time as their villages were to Californians.

VISITING SANTA FE AND TAOS IN 1917

As David Turner describes in his essay, Wores' trip to Santa Fe and Taos brought him to the heart of Indian Country. But unlike his trips to Japan and the Pacific Islands, and even his trips into San Francisco's Chinatown, Wores was far from the first to arrive.

These were important times in Northern New Mexico and Santa Fe in particular, where the new Museum of Fine Arts was being built, a duplicate of one of the buildings just created under Edgar Lee Hewitt's direction at the 1915 San Diego Panama-California Exposition. Hewitt was an archeologist and a major force in Santa Fe. Director of the Museum of New Mexico and the School of American Research, he had been brought to San Diego to create its Museum of Man as well as to contribute to the style and architecture of the Fair. In Santa Fe, he wielded

tremendous influence in the development of cultural resources. His attraction to the growing artist's colony gave him yet another avenue to expand his cultural kingdom from its base in archeology and ethnography into the arts. Wores stopped in Santa Fe long enough to visit with the new museum's curatorial staff and snapped a few photographs of the Museum of Fine Arts under construction. Santa Fe was a stop on the way to his goal to get to Taos, the home of an Indian village he had heard survived in all its ethnographic glory, where the Taos Indians would be subjects for his paintings.

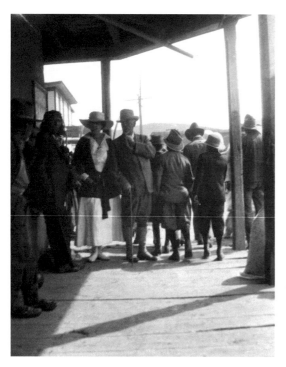

Julius Rolshoven (center) in
Taos, New Mexico
1917
Theodore Wores
Courtesy of Fred M. Levin

Wores was also drawn to Taos by the growing number of artists living there, and especially those who had formed the Taos Society of Artists, including Joseph Sharp, Bert Phillips, Ernest Blumenschein, E. Irving Couse, Oscar Berninghaus and W. Herbert "Buck" Dunton. This was the early phase of Taos as a destination for artists attracted by landscape, the high desert's unusual light, the unique adobe buildings, the Native peoples and the old Spanish villages. Among those living in Taos whom Wores knew from his student days in Germany were Julius Rolshoven and Sharp, who both welcomed Wores into the fold for a few months of the artist life in the high desert.

Trekking to the High Desert was something that reached its peak among artists and literati in the times just after Wores' stay. That development was led by the wealthy heiress, socialite and cultural maven Mabel Dodge. Dodge, from New York, had been deeply involved in social causes and the rarefied world of the arts and thinkers. She arrived in Taos, settled in, met and married Tony Lujan, a Taos Indian, and became Mabel Dodge Lujan. Today, her name is synonymous with the romance, liveliness and verve of the New Mexico arts scene in the early 20th century. She wrote in her memoir, *Edge of Taos Desert,*[3] "I had always heard of people going to Florida or California, and more occasionally the West, but no one ever went to the Southwest. Hardly anyone had ever even heard of Santa Fe." Just after Wores departed New Mexico, Mabel Dodge arrived and became an impressive force unleashed on the high desert town of Taos. Her networks among the literary, artistic and fashionable sets soon led to D.H. Lawrence coming to Taos, and Mary Austin, Andrew Dasburg, Leon Gaspard, Robinson Jeffers, Oliver LaFarge, Edna St. Vincent Milay, Willa Cather, Witter Bynner, John Reed, Ansel Adams and, most famously, Georgia O'Keeffe.

Because Wores did not travel to Taos with his wife, Carrie, we have a record of his time there that late summer and early fall. He dutifully wrote letters to her nearly every day, describing his evening activities among the artists and the paintings he was working on. He hobnobbed with the artist community, feasted at great lunches and parties, and spent his days painting at the Indian Pueblo. While this was not as

intense and prolonged an immersion as his experience in Japan, he worked again as he had in the past, dressed always in suit and tie, with his paints and easel, out of doors, directly with the local indigenous people.

Wores was fortunate to have been introduced to a generous Taos Pueblo man, Ralph Martinez, whom he hired as his guide, model, and agent for hiring other Taos Indians to pose for his paintings and photographs. Martinez appears to have been a fine, dedicated, and loyal aide and assistant, working with Wores most days, and driving him back and forth from the town of Taos to Taos Pueblo with his wagon and team.

Wores nearly neglected to record Martinez' name, calling him "my Indian" in most of the letters, denoting Martinez' role as his servant in keeping with popular, stereotypical language of the day. Wores appears to have gained respect for Japanese, Hawaiian, Chinese and Samoan peoples, and it appears that the Taos Indians were joined in his mind to those groups of noble and exotic peoples. From today's perspective, one senses more than a touch of racism and condescension, yet it is unlikely Wores meant any deep offense. A product of his time, he, among many, saw the Taos Indians as the last peoples of a former time, soon to be stripped of their traditions. This was a common belief that motivated many artists, including the noted photographer Edward Curtis. Native Americans appeared to be losing a battle with modernity, and, as a combination of ethnologist and artist, Wores' goal was to capture them before time changed them forever. In this fashion, Wores posed Martinez, as he had some of the Southwestern Indians at the PPIE, in ways that played upon those themes – as a "scout," or as an elder teaching youngsters how to use a bow and arrow – engaged in activities that reflect more about the white man's stereotype of Indians than they reveal about their real lives.

Not until one of Wores' last letters does he parenthetically refer to Martinez by name. In a missive postmarked October 13th, 1917, he wrote "I asked my Indian (whose name by the way is Ralph Martinez) to get a model for me, a cousin and a rather fine looking girl." By finally naming his guide, Wores allowed us to search out the stories and histories of those people in Taos who posed for his work. Research has not produced the names and stories of the Indians who traveled to San Francisco for the PPIE, nor those who Wores painted at the Grand Canyon, but the people in the Taos paintings are almost all now identified with fairly high certainty. For this we owe the careful research and openness of Paula Rivera, a member of Taos Pueblo, a museum professional in Santa Fe, and field researcher for this project.

After a fruitless search for Martinez in the usual written demographic and community records, Rivera asked her grandfather, Lorenzo Alfred Lujan, if he had ever heard of a man named Ralph Martinez. She held out photocopies of some of

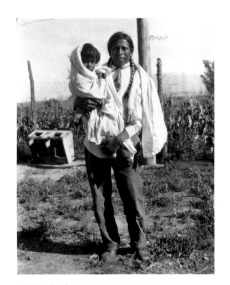

Ralph Elk Flying Water Martinez
with "Little Ralph," his adopted son
Taos Pueblo
1917
Theodore Wores
Courtesy of Fred M. Levin

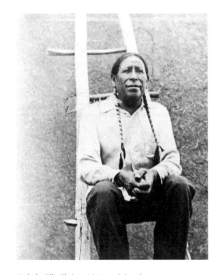

Ralph Elk Flying Water Martinez,
c. 1920, photographer unknown,
gelatin silver print
Courtesy of Lorenzo A. Lujan

the paintings Wores made of Ralph in 1917 to show her grandfather. He rummaged briefly through some family photographs, pulled one out, and said, "That's your great uncle Ralph." From that moment, Paula's grandfather led us through his family tree, and graciously provided us with what he knew about Ralph Martinez and his life and family around the time of Wores' visit.

Unfortunately, it is rare that scholars seem interested in the people in paintings, or at least in paintings of Native Americans and "exotic" peoples. The focus in art history is usually the artist rather than his or her subjects, although studies of European and American art portraits of the important and wealthy certainly focus on those posing for the paintings as well as the painter. In this case, and especially with Wores' Taos paintings, an unintended family album was created. Over and over again, Martinez called upon his family members to pose as models for Wores' brush; each, of course, was paid the usual meager fee. But through Lorenzo Alfred Lujan's memory and skills of recounting family history, we gain at least some knowledge of Ralph Martinez, his adopted son, and his extended family.

Martinez never married, but as was common in Taos and among many traditional people throughout the world, he adopted children to care for as his own, sharing the burden and pleasures of child rearing within his extended family. One son – whose "English" name was Little Ralph – was depicted in a few of Wores' paintings, and in many of Wores' photographs. Others who likely posed as models were Martinez' four sisters, sometimes described in interviews in 2003 with Alfred Lujan by either translated Tiwa names – Yellow Locust Tree (later to become Mrs. Ralph Pando) and Indian Perfume, or by their "English" names, Emily (Indian Perfume's English name), Juliana and Josephine. Martinez' cousin Elk Grass also posed for Wores.

Mention of Ralph Martinez' relatives in Wores' letters can be deceiving or incorrect, likely a result of misunderstandings, or likely, as Alfred Lujan explained, because relationships in Pueblo Indian families don't always translate well outside of Pueblo culture. It is likely Martinez was just making things simpler for Wores by calling people "my son" or "my sister" or "my cousin."

Ralph Martinez was a farmer and rancher whose translated Tiwa name was "Elk Flying Water." The son of Lorenzo and Marquita Martinez, Ralph Martinez lived on the south side of the Pueblo, in a house that still stands. As was common, Martinez also maintained a "summer house" near his fields, outside the main Pueblo's walls. According to his nephew Lorenzo Alfred Lujan, Martinez was very fond of and accomplished in the keeping of horses, and he took great pride in his wagon team.

Ralph Martinez' brother, Albert Looking Elk (Martinez), worked for a time for the artist Oscar Berninghaus, and he became an accomplished painter himself when Berninghaus gave him paints, brushes and lessons. This tradition of painting

has been passed along to Lorenzo Alfred Lujan, who has painted throughout his life, continuing to work in oils and watercolors. This "folk" style of painting is actually far from any true tradition – it was influenced at first by the great number of American and European trained artists who worked with Indian models, and later by the teacher Dorothy Dunn at the Santa Fe Indian School.

Lorenzo Alfred Lujan knew all of the people mentioned in Wores' letters, but those in Wores' photographs and paintings were from a time long ago, and Lujan, of course, knew these people as adults or elders. While it was difficult for Lujan to determine for sure which of Martinez' family posed for Wores, it is fairly certain they were all family members. For example, Alfred Lujan stated in interviews that the photographs of the little boy with Ralph practicing with bow and arrow, and the paintings of that scene are probably of Little Ralph.

Paula Rivera with her grandparents,
Mr. & Mrs. Lorenzo Alfred Lujan
Taos Pueblo, November, 2003
Photograph by the author

What makes these photographs important to the people of Taos and their families today are the obvious things – they are link to the past, a never-known treasure of images of a time, place and people that are now being shared with them for the first time through this project and exhibition. Much has been made of late of the need for reclaiming a people's past, and through these paintings and photographs, a family album has been assembled. This, of course, was never Wores' intent – he planned a great exhibition of the paintings in New York where he could sell them as a record of an exotic people residing here, on our continent, in our country – but, of course, anonymous, without names or identities. He had been hopeful, as he wrote to Carrie in a letter dated October 13, 1917:

> *Last night I was at the Rolshofens [sic] & we spent a pleasant evening with a half dozen of the artists. They spoke of the possibilities of Taos as a market for pictures & from what I heard of successes that some of them have had, I should say that anyone who had a studio here & a lot of Indian pictures would have a good chance to make sales, as quite a lot of visitors come here to see the Indian Pueblo and they are all interested in seeing the studios & Indian pictures.*

But Wores' plan to sell his Southwestern Indian series did not work out. Only two paintings sold in his 1918 exhibition in New York. Newspaper reviews were far from encouraging, and although he exhibited the paintings back home in California at the Bohemian Club, the Stanford Art Gallery and the William Keith Gallery, the series remained together and unsold. After he passed away in 1939, his widow gave Wores' Southwestern Indian paintings as a group to the Natural History Museum of Los Angeles County. Exhibited in total perhaps only one time since then, and

rarely seen for many decades, this book and its accompanying exhibition serve to uncover these unique and intriguing images that reflect both sides of the canvas, the artist and his models, from two worlds, joined together nearly a century ago for a brief moment, yet creating a lasting record of time and place.

1 Bruce Bernstein, *The Marketing of Culture: Pottery and Santa Fe's Indian Market*, Ph.D. dissertation, The University of New Mexico, 1993

2 Van Deren Coke, *The Painter and the Photograph*, University of New Mexico Press, 1964

3 Mabel Dodge Lujan, *Edge of Taos Desert: An Escape to Reality*, University of New Mexico Press, 1987

The New Mexico Wores Saw

DAVID TURNER

In the fall of 1917, the same season and year Theodore Wores visited Taos to paint, two significant events took place in northern New Mexico that clearly defined that unique setting. In September, the Santa Fe-based film company, El Toro, created a travelogue film of Taos and northern New Mexico, an early form of cultural tourism as this area was becoming known as an active art colony. And in November in Santa Fe, the Museum of Fine Arts opened on the downtown plaza as a place to celebrate the high level of art activity in New Mexico.

The rare film footage from *A Trip Through Kit Carson Land*, once discarded as trash and recovered by an employee of the State Highway Department, pictorially describes a specific time and place in New Mexico history, one that sets an accurate context for Wores' only excursion to the Land of Enchantment in September and October, 1917. While Wores talks about his quick scene in the film as part of the artist group, we also know from his letters to his wife that he knew the film was being made, had met most of the artists who appeared in the film, and attended the San Geronimo Day festivities that were recorded by the filmmakers.

Two months later further south in Santa Fe, a magnificent new building opened that performed two distinct functions: 1) its architectural style of rounded stuccoed walls and interiors with wooden ceilings full of hand-carved details helped create the still-popular Santa Fe style of architecture, and 2) its new galleries demonstrated a commitment of the state to collect and exhibit the art being produced in New Mexico by both locals and the significant artists visiting this new art colony.

To better understand the context of Wores' visit to Taos and Santa Fe, one should be mindful of this descriptive body of work that exists to authenticate this very specific period. The aforementioned film documents the area and people, the opening of the Museum of Fine Arts draws together the artists, Wores' personal letters describe his daily observations in Taos and Santa Fe, and the group of twenty-three paintings completed during his forty-one day stay (he completed twenty-four other paintings of Southwestern subjects) exemplify an artist's work ethic and selection of artistic subjects.

First the film, for its scenes depict the dual nature of Taos during this time, one where locals may struggle for survival of their native ways while visitors enjoy the lure of the rural village rich with cultural history and artistic tradition. While the film company shot more than twelve thousand feet of film in September, 1917, only seven thousand feet survive in an incomplete edit that documents a group of motorists touring the primitive roads around the famous New Mexico art colony

of Taos. Commissioned by the short-lived New Mexico Publicity Bureau, a division of the State Land Office, to encourage tourist and economic development of the state, this film cost over $6,800 to produce, almost one-half of the Publicity Bureau's entire annual operating budget. Similar to the United States Information Agency's (USIA) films produced in the 1950s and 1960s to be shown abroad to introduce American values to the world, this film portrays the landscape around Taos as the three-seated touring car motors through the Sangre de Cristo mountains, near the Rio Grande canyon near Taos, and the newly built Eagle Nest and Cabresto Dams.

Most intriguing in the film are the scenes portraying the city's celebration of the Feast of San Geronimo at Taos Pueblo and the activity of the artists of the original Taos Society of Artists (TSA), both representing events and people familiar to Wores during his two month stay in Taos. On September 30 every year, the Pueblo celebrates the feast day of San Geronimo, in honor of Saint Jerome, the patron saint of the Taos Pueblo Catholic Church. The day-long festival includes feasts open to family, friends, and guests, a foot race on a road leading east from Pueblo, and the famous pole climb where Pueblo "clowns" try to scale a large pole in the center of the Pueblo plaza to attain gifts at the top.

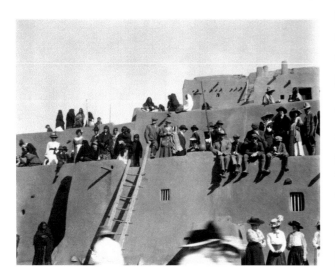

Above and right:
San Geronimo Day, Taos Pueblo
September 30, 1917
Theodore Wores
Courtesy of Fred M. Levin

Wores arrived in Taos in time for the Pueblo's annual September 30th San Geronimo Day celebrations, which include races, pole climbing, and a trade fair. These photographs are rare examples of Wores using his camera for snapshots.

The filmmakers clearly recognized that part of the attraction to Taos was its growing art community so they filmed different scenes of the high-profile group of artists. Several scenes show Taos Society of Artists members painting and partying, and Wores writes in his letters of himself appearing in a scene.

While in Taos, Wores tried to meet as many of his fellow artists as he could. To his good fortune, he was in Taos during the heyday of the colony of artists who migrated to northern New Mexico, mainly from the midwest and east. Attracted to the area by a variety of exotic features unavailable back east, these artists became as common in the town life of Taos as the local Indians, native Hispanics, and their indigenous architecture.

What Wores and other Taos artists witnessed in Taos in 1917 was really centuries in the making. New Mexico, the Land of Enchantment, had attracted settlers and visitors for thousands of years. An ancient land that has been home to three strong cultural settlements, the landscape has long been inhabited by peoples along the Rio Grande, who have lived close to the land and observed its subtle but extreme changes.

The earliest peoples living in the New Mexico area were the Native Americans, whose evidence from 12,000 B.C.E. can be found in the eastern part of the state, at

Blackwater Draw, near Clovis, at the Folsom Site. The Clovis culture made distinct stone tools with fluted edges that were attached to shafts for use as spears.

By 3000 B.C.E., these pre-historic settlers lived on the arid land of the Southwest as either nomadic hunters or agricultural planners, and at times both. The people in the Southwest hunted bison, deer, small game, and birds, and spent increasing amounts of time collecting wild plants for food. About this time, they learned to grow corn and used stone slabs to ground it and other grass seeds into flour.

The climate gradually became warmer and drier and the Mogollon people, living chiefly in the mountainous area of southeastern Arizona and southwestern New Mexico, settled into communities near water to grow more food. The Mogollon are best known for their distinctive Mimbres pottery (1000-1200), with black-on-white geometric designs of birds, bats, frogs, and ceremonial scenes.

The Anasazi people, now known as "the old ones," settled as farmers and potters in the Chaco Canyon area, along the northern New Mexico and Arizona border.

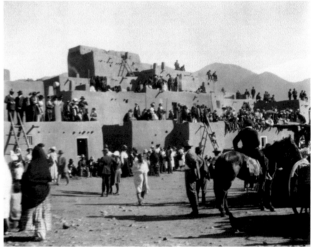

These villages joined together in a network stretching 250 miles from north to south. Scattered along Chaco Canyon, nine great houses, rectangular blocks of hundreds of rooms looming as high as five stories and centered on big plazas, anchored the network. An estimated 150 villages throughout the Southwest were tied into the Chacoan system, evolving into the Pueblo cultures along the Rio Grande, including Taos Pueblo.

Since 1540 there has also been dominant Spanish influence in the New Mexico region as the Spanish colonized the Pueblos in the footsteps of Francisco Vasquez de Coronado's search for the Seven Cites of Gold. Through the late fifteenth and early sixteenth centuries, Spain was focused on seeking wealth and souls in this area. The Treaty of 1496 had earlier allowed the Pope to divide the world between Spain and Portugal. The condition to claim the land was that the "natives" had to be converted to Catholics. So these Spanish exploratory expeditions aimed to acquire land and set up Catholic churches all over the area for the conversion of the Indians. The church at Taos Pueblo, a popular backdrop for many painters and photographers in the twentieth century, including Wores, was first built by the Spanish in 1627, and destroyed and rebuilt twice since then.

While the design of these churches echoed European Baroque Catholic churches with long naves focusing attention on the elaborate painted altar screens, the exteriors were finished with the smooth handiwork of stucco, a Pueblo architectural tradition but now applied by the Spanish. Hispanic artists found new work painting and carving the Catholic saints for these churches, plus the numerous family private chapels in the area.

A number of New Mexico cities were built in the Spanish fortress style, most noted is the one in the old Plaza at Chimayo, from 1730, where residences and stores faced the plaza that could easily be closed off from outside invaders. Plazas were also characteristic features of cities like Taos and Santa Fe, where they served more public social needs rather than defensive purposes. Santa Fe was established around its plaza as the Spanish capital in 1610 and the village of Taos was founded by the Spanish on the northwest side of today's main Taos Plaza in 1796.

The Spanish and Indian cultures lived along side each other since the late sixteenth century, and they have had both friendly meetings and bloody battles. One of the most significant battles was the Pueblo Indian Revolt of 1680, where the Pueblo Indians forced the Spanish into exile for thirteen years before being reconquered peacefully by Don Diego de Vargas in 1694.

Eventually the Spanish and Pueblo Indians learned to coexist peacefully in the same land mainly because they had a common enemy, the nomadic Indians, like the Comanches, who raided their farms. Evidence of this coexistence can be seen in the Spanish mission churches built on the Indian reservations and the agricultural exchange: Spain introduced to the Pueblos horses, cattle, and wheat; Indians taught the Spanish how to raise corn, squash, beans, and chiles. Additionally, the Taos Pueblo was the site each summer of a major trade fair, where Apaches, Utes, other Pueblo Indians, French, Spanish and Anglos all met to exchange goods such as horses, knives, buffalo skins, beaver pelts, and jewelry.

When New Mexico became part of the United States in 1848 as a Territory, its borders opened for more trade. First the area was opened up to settlers from the Midwest and East, and then to tourists, visiting these new settlers and seeking new experiences in the Spanish villages and Indian Pueblos. This created a place for the third influential group in New Mexico, the Anglos, who came to the area in great numbers after the Old Santa Fe Trail opened in 1821 leading traders from the plains of Kansas to the Plaza in downtown Santa Fe. This trade connected the west to the urban east as settlers hauled their pianos and Queen Anne furniture across the plains to their new homes.

The success of the Old Santa Fe Trail for Conestoga wagons and trail rides led to the creation of the Atchinson, Topeka and Santa Fe Railway, which opened up in 1879. This was the cross country train line from Chicago to Los Angeles, stopping in Lamy, right outside Santa Fe, that created the newest, and still most important, commerce for the state, tourism. Before long, festive ceremonies and events were put on more as a spectator sport for the tourists than for the original reasons of family and spiritual gatherings. The "art of watching" became a main past time for visitors and developed a new need for a pictorial record of what they saw. Enter painters and photographers, whose images satisfied a demand for pictures as souvenirs.

Of special note is how Northern New Mexico became heavily advertised through the popular Santa Fe Railway calendars featuring paintings of the regional landscape and portraits of its Indian and Spanish residents. The mayor of Chicago, Carter H. Harrison, Jr., knew the impact art could make in developing an image for his city and grew interested in the art of Taos as he often traveled to the area. He had been an early supporter of Chicago-based painters who worked in Taos and sent paintings back to Harrison in Chicago. Among these artists were Victor Higgins, Walter Ufer, and E. Martin Henning, all members of the Taos Society of Artists.

The home office of the Atchinson, Topeka & Santa Fe Railway Company, in Chicago, also supported Taos artists as their chief advertising agent, William Haskell Simpson, started a campaign to promote the idea of the "Santa Fe Southwest," utilizing paintings commissioned of the area by Taos artists. Simpson found two significant uses for these paintings: one, they could decorate the waiting rooms and station offices along the Santa Fe Railway's route; and two, having purchased the paintings and their reproduction rights, they could be used as illustrations in their brochures and the annual promotional calendars. These calendars started in 1907 and were printed in large editions of up to 300,000 and distributed to homes, schools, and businesses throughout the country. While many Taos artists were commissioned, E. Irving Couse received the lion's shares of Simpson's commissions.

When travelers journeyed to New Mexico, they usually found their way to Taos, the small mountain community about sixty miles north of Santa Fe, and a six hour journey from the Lamy station, where the romantic idea of the West lingered on. By 1900, Taos was a town combining the flavors of the Old West, the Native American architecture and crafts, Hispanic colonization, and the new idea of an art colony.

Taos as an art colony was newly blossoming in the first years of the twentieth century. Already an area rich in the arts and crafts of the indigenous Indians and Hispanics, Anglo artists were drawn here because of the old world traditions, the omnipresent clear light bathing the landscape, and a new sense of American pride, growing from the more precarious traveling conditions in Europe as war conditions begin to develop. Already art colonies had become established in other rural areas far outside the mainstream of the art market, in places like Woodstock, New York, Brown County, Indiana, Cos Cob, Connecticut, and several communities in Maine. Attracted to a lure of the Southwest, artists found their way to Taos and Santa Fe and began art colonies there.

The origin of the Taos art colony is as romanticized as the land they painted. Many renditions exist of who was there first, who first had the idea to come together, and

who were considered the original founders. The good story of its founding goes a lot like this: Joseph Sharp is usually considered the father of the Taos Art Colony.

He first visited there in 1893, creating the painting, *Harvest Dance*, immediately purchased by the Cincinnati Art Museum, and began spending summers there by 1902. When studying art in Paris in 1895, Sharp told fellow students, Ernest Blumenschein and Bert Phillips, about the brilliant area and encouraged them to explore it. Then in 1898 Blumenschein and Phillips decided to take a sketching tour of the West, with a final destination of northern Mexico. First they rode the train to Denver and camped nearby at Red Rocks, where they purchased a wagon and team of two horses with the intention of heading for Mexico.

Going south over the small road outside of Questa, New Mexico, on September 3, 1898, their wagon wheel broke. Taos was the closest town, about twenty miles away to the south, so they tossed a coin and it fell to Blumenschein to take the wheel to Taos by horseback. It was a slow journey and Blumenschein had time to observe the beautiful New Mexico landscape in autumn. When he returned with the repaired wheel, they rode in together with the idea of staying. Both artists rented an adobe house to use as their home and studio and agreed to end their travel in Taos. Days

Museum of Fine Arts, Santa Fe, 1917
Theodore Wores
Courtesy of Fred M. Levin

Museum of Fine Arts, Santa Fe, 1917
Theodore Wores
Courtesy of Fred M. Levin

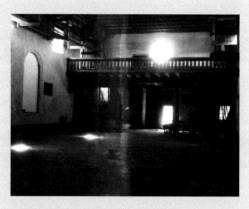

Interior of the Saint Francis Auditorium,
Museum of Fine Arts, Santa Fe, 1917
Theodore Wores
Courtesy of Fred M. Levin

When Wores arrived in New Mexico, the new Museum of Fine Arts of the Museum of New Mexico was under construction. The Pueblo Revival style building on the plaza in Santa Fe designed by I. H. and William M. Rapp was based on their New Mexico building at the 1915 Panama-California Exposition held in San Diego, the "companion" fair created by San Diego in answer to San Francisco's Panama-Pacific International Exposition. The museum's architecture reflected elements of the facades of the Spanish mission churches at Acoma, Laguna and San Felipe Pueblos.

later, Blumenschein would make his first commercially successful sketches of the area to be sold and printed in the December 1898 issue of *Harper's Weekly*. These were of the San Geronimo Day festival at Taos Pueblo, an event to be observed and painted by Wores nineteen years later. After three months, Phillips decided to stay and became the first artist to make permanent residence there. This broken wagon wheel story is now legend and celebrated often in Taos, most notably in the annual Fiesta parades.

Within a year, Phillips and Blumenschein had both sold paintings through their Chicago dealer, M. O'Brien & Son, and their success had begun to attract other painters. By 1915 Taos had attracted a strong group of artists and six of them – Joseph Sharp, Ernest Blumenschein, Bert Phillips, Oscar Berninghaus, Irving Couse, and Herbert "Buck" Dunton – formed the original Taos Society of Artists. Over their twelve year history, disbanding officially in 1927, the group had expanded to include Walter Ufer and Victor Higgins, and then expanded again to include E. Martin Hennings and Kenneth Adams, making them "The Taos 10". Eventually the group grew to twenty-one members including Catherine Critcher, Julius Rolshoven (who was a good friend of Wores) Robert Henri, John Sloan, Randall Davey, B.J.O. Nordfeldt, Gustave Baumann, Birger Sandzen, and Albert Groll. They also added honorary members, Edgar Lee Hewett, Director of the Museum of New Mexico, and Frank Springer, a founder of the Museum of New Mexico and on its first Board of Regents. The official bylaws of the Taos Society of Artists state:

> This Society is formed for educational purposes, to develop a high standard for art among its members, and to aid in the diffusion of taste for art in general. To promote and stimulate the practice expressions of art—to preserve and promote native arts.
>
> To facilitate bringing before the public through exhibitions and other means tangible results of the work of its members. To promote, maintain, and preserve high standards of artistic excellence in painting, and to encourage sculpture, architecture, applied arts, music, literature, ethnology and archaeology solely as it pertains to New Mexico and the States adjoining.

The goals of the group were both lofty and conservative. They were painting in the romantic style of the nineteenth century and living in the present in the vanishing west. Remember, too, these were artists who were among the group of painters who would travel to Europe or North Africa for exotic influence, but now they traveled to the Southwest to observe and live among America's natives.

The idea of an art colony is one about camaraderie and mutual support. These were places where artists spent time together, away from normal daily distractions, so they could work on their art. The strength of their individualism only made the

group efforts stronger. To gain the sense of the Taos art community during the first decades of the twentieth century, it is helpful to meet the artists most involved.

JOSEPH SHARP (1859–1953) was born in Bridgeport, Ohio and his family soon moved to Cincinnati where he grew up. He studied art at the Art Institute of Chicago and then traveled to Europe to study in the French and German academies. His first travel to the West was in 1883 and he reached Santa Fe to sketch Indians and visit the local pueblos. He continued on to California and to Oregon, where he sketched members of the Klikitat, Nez Perce, Shoshone, Ute, and Umatilla tribes.

After meeting German-born artist Henry Farny, an accomplished painter of the "vanishing west" and who rekindled Sharp's interest in the American Indian, Sharp traveled to Taos in 1893, earning the distinction to be the first of the Taos Society of Artists to have visited Taos. He became a permanent resident in Taos in 1912.

His goal in life became to record Indian life before it had been significantly altered by modern influences. When he came to Taos, he realized the Pueblo Indian life was pretty stable and started spending time painting the Crow and Sioux on the reservations in Montana, lasting from 1901-1916. These paintings were purchased by the Smithsonian Institution in Washington. Unlike Couse's portraits of Indians, Sharp's were, on the most part, historically accurate as he tried to document the dress and customs of their disappearing lifestyle.

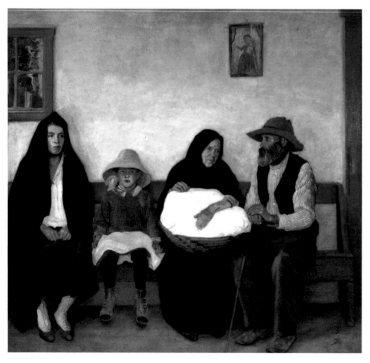

Our Washerwoman's Family – New Mexico, c. 1918 Bert Geer Phillips oil on canvas Collection of the Museum of Fine Arts, New Mexico. Gift of Governor and Mrs. Arthur Seligman, before 1930.

BERT GEER PHILLIPS (1868-1956) was raised on the Hudson River in New York, where he spent time roaming the woods while drawing and sketching. His father insisted on an architectural career but young Phillips rebelled and studied art in New York at the Art Students League and the National Academy of Design. In 1894 he went to Europe and met Joseph Sharp and Ernest Blumenschein in a painting class at the Academie Julian and they became lifelong friends. Back in New York, Phillips shared a studio with Blumenschein and pursued their interest in western subjects by painting portraits of cowboy and Indian models from Buffalo Bill's Wild West Show touring New York.

Philips and Blumenschein were inspired by Sharp's stories of the American West, told while all were students in Paris. Phillips especially became fascinated with the story of Kit Carson, who was employed as hunter for the garrison at Bent's Fort, Colorado, and accompanied the American explorer John Charles Frémont on expeditions, serving as a guide in Frémont's expedition to California. In addition to

his fascination with Kit Carson. Phillips also painted the Hispanic cultures. These Spanish and Mexican descendants had been in northern New Mexico for four hundred years and were firmly rooted in the Taos community, many living on large Spanish land grant farms providing for most of the area's agriculture. His wonderful painting, *Our Washerwoman's Family – New Mexico*, 1917, portrays the Hispanic cultural values that are based on family and church and the customs which celebrate them both.

ERNEST L. BLUMENSCHEIN (1874-1960) began his career torn between a love for music and a love for painting. He did not leave music behind until he played first violin in 1892 in the New York Symphony Orchestra under the director of Anton Dvořák. A native of Dayton, Ohio, he studied at the Arts Students League in New York and the Academie Julian in Paris, where he met Couse, Sharp and Phillips.

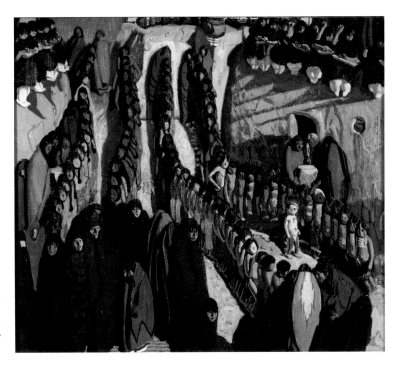

Dance at Taos
1923
Ernest Blumenschein
oil on canvas
Collection of the Museum of Fine Arts,
New Mexico. Gift of Miss Florence
Dibbell Bartlett, 1947

He visited New Mexico first in 1898 with Bert Phillips, of broken wagon wheel fame, on assignment from *McClure's* magazine to record Indians of the Southwest. Blumenschein returned to New York to continue his successful commercial career, with regular trips to Paris. By 1910 he figured out a way to spend more time in Taos by working intensively in New York for nine months of each year so he could spend three months on his own in Taos. By 1912, we was one of the six original founders of the Taos Society of Artists and by 1919, he was able to give up his commercial career because of his wife's inheritance, and move permanently to Taos.

"We all drifted into Taos like skilled hands looking for a good steady job.," says Blumenschein, "We found it, and lived only to paint." His full-time residency in Taos caused his paintings to change from romanticized portraits of the Indians to a more respectful view of their ceremonies and daily life. His *Sangre de Cristos*, ca. 1925, positions a dramatic landscape with a band of bright light illuminating the adobe village before the mountains, while the secretive procession of the Penitentes on Good Friday remain in deep shadow.

More than the other Taos Society of Artists painters, Blumenschein added a stylized graphic look to many of his paintings that connected him to the new breed of Modernist artists now coming to Taos. His view of the Indian dances, like *Winter Solstice, Dance at Taos*, suggest the patterned movement of the dance and the anonymity of the dancers. These Indian dances required keen visual memory for even then, it was not always easy to photographically document these family

ceremonies. So these scenes of dances by the Blumenschein and other Taos Society of Artists were competed back in the studio, often from memory, and led to stylized scenes rather than ones emphasizing documentary concerns. While these dances were primarily celebrations and rituals of the Pueblo, they enabled the individual dancers and family-member viewers to come to peace with a certain problem or to provide nourishment to the land.

OSCAR BERNINGHAUS (1874-1952), a native of St. Louis, Missouri, was primarily a self-taught artist with little academic training and no travel to Europe. He did build a successful commercial career in Missouri and kept those contacts active while in New Mexico. His first trip to Taos was on the "Chile Line" Railway, which ran from southern Colorado into Northern New Mexico, in 1899 as a guest of the Denver and Rio Grande Railway. Although he stayed only one week, his fascination with New Mexico drew him back each summer until he moved there permanently in 1925.

Interested in the transition of the cultures, watching the native peoples adapt to the influx of the Anglo visitors, Berninghaus specialized in classic scenes that show Indians and Hispanics at work, rarely posed as models in a studio. His outdoor scenes were carefully constructed and almost perfect in their compositions and in the painterly planes of space.

IRVING COUSE (1866-1936) was raised among the Chippewa and Ojibwa Indians in Saginaw, Michigan. He knew and loved the art of the West and aspired to become a painter at an early age. After studying painting at the Art Institute of Chicago and the National Academy of Design in New York, he went to the Ecole des Beaux Arts in Paris and met other Taos artists. In France he learned much about figure painting, including the habit of posing a model in a crouched or kneeling position close to the picture plane. Upon his return to the States he traveled to Oregon and painted portraits of the Klikitat Indian tribe and then, in 1903 at the urging of his friend Joseph Sharp, traveled to New Mexico. He spent every summer there, becoming the main artist for the calendar art of the Santa Fe Railway, moving to Taos permanently in 1927.

His work in Taos is more interested in the artistic presentation of the Indian rather than historical or ethnographical accuracy, so he created an idealized arrangement of the figures, based on his knowledge of French models, and dressed them in costumes holding and wearing artifacts from his extensive ethnographic collection in what would become a formula for him. His models, usually the same two individuals used over and over again, inhabit a picturesque world created by the imagination of the artist. They no longer propose to be noble savages, but instead noble ornaments.

HERBERT "BUCK" DUNTON (1878-1936) grew up in the natural landscape of Maine and began sending drawings to newspapers in New York and Maine. At eighteen, he traveled to Montana and worked as a cowpuncher and, like Charles Russell, sketched the wilderness environment and the working cowboy. Upon his return to the East, he took a class at the Arts Students League taught by Ernest Blumenschein and became inspired by his stories of the Taos valley. For fifteen years after this, he worked the winters as an illustrator of Zane Grey stories and spent the summers traveling the west gathering inspiration for his art. He became the sixth and last charter member of the Taos Society Of Artists.

Two members were added to the original six of the Taos Society of Artists, **Walter Ufer** and **Victor Higgins**. Ufer (1876-1936) was born of German immigrant parents and raised in Kentucky He began drawing as a boy and apprenticed as a lithographer, but gave up printmaking and studied painting in Germany. Upon his return to the states, he went to Chicago and exhibited his paintings to great praise, eventually winning him a travel opportunity to New Mexico as guest of the Santa Fe Railway. By 1917, he was an Active Member of the Taos Society of Artists and divided his time between Taos, New York, and Chicago, participating in many exhibitions at the museums in major cities in the east and Midwest.

Ufer's paintings were strong because of his excellent sense of color and his superb draftsman skill, developed in his lithography. Rarely working from sketches, he painted directly on the canvas with bold colors and thick impasto. Most of his work portrays the Indians of Taos Pueblo and he shows respect for them as intelligent participants in the community, not mere subjects of curiosity.

VICTOR HIGGINS (1884-1949) was raised in a farming community in Indiana, where his first interest in art was sparked by an itinerant sign painter, who encouraged him to paint the inside walls of their barn from top to bottom. Then he studied art at the Art Institute of Chicago, later went to New York where he studied with Robert Henri, and then spent four years in Europe. When he returned to New York, he saw the celebrated Armory Show of 1913 and became fascinated with the possibilities of modern art. He arrived in Taos in 1913 as a guest of the Santa Fe Railway and the following year became a permanent resident.

Higgins talked about what enthralled him about the Taos area and noted there was the best light to be found anywhere and there were more colors in the landscape than elsewhere. He is considered the most "modernist" of the Taos Society of Artists, representing both sides of the painting styles—traditional and modern. Later in his career, he moved away from the more anecdotal or picturesque work of fellow TSA artists and began being more painterly, looking for significant forms in the composition, attempting not just to make a picture but to solve a problem.

The final two artists to be added to the original group, now ten, were E. Martin Hennings and Kenneth Adams. Hennings (1886-1956) was raised in Chicago and studied there at the Art Institute and, later, in Germany at the Munich Academy. He first visited Taos in 1917 and became a resident in 1921.

Hennings was equally at home painting landscapes and portraits. In his landscapes, he generally worked on the background first, laboring over the correct placement of the various elements of trees, mountains, roads, and finally the figures. Thus, the paintings excel in their spatial organization.

KENNETH ADAMS (1897-1966) was born in Topeka, Kansas and studied at Art Institute of Chicago. After serving in World War I, he enrolled in the New York Art Students League and studied painting at their summer institute in Woodstock, New York with Andrew Dasburg, who encouraged him to go to Paris, where he became an admirer of Cezanne.

Dasburg had invited Adams to Santa Fe in 1924 but Adams could not find a place to live, so with a letter of introduction from Dasburg, he went to Taos and met Ufer. They became good friends and Ufer nominated him to Taos Society of Artists at their 1926 annual meeting, a time when they were experiencing declining sales and few exhibitions. This was their last meeting and the group disbanded in 1927.

These individuals were the types of artists attracted to Taos at the beginning of the century. They primarily came from urban backgrounds, academically trained in New York, Chicago, Paris, or Munich and they were all in search of an opportunity to live and work in a multi-cultured community where their art was appreciated.

Into this scene came Theodore Wores on one of his many artistic journeys to explore cultures, architecture, and customs different from his California experience. He had been to the Southwest before, once in the fall, 1916 to see Acoma Pueblo in New Mexico, then with his wife, Carrie, to the Grand Canyon. This time, in September, 1917, he traveled alone, leaving Carrie back at their home in San Francisco, California, because she was not feeling healthy enough to travel. She was to meet him later in his trip. Her absence on this trip was fortuitous for it caused Theodore to write almost daily letters home to her, describing his activities and impressions in Taos.

A summary of Wores' activities in Santa Fe and Taos, as described in his letters, charts the people Wores met and the scenes he witnessed.

FRIDAY, SEPTEMBER 7, 1917:

❖ Wores arrives by train in Lamy and stays at the Montezuma Hotel, Santa Fe

❖ visits Museum of New Mexico art curator, Paul Walter, who gives Wores advice on Taos. Walter is also planning for the opening of the new Museum of Fine Arts, scheduled for November 17, 1917. Walter asked Wores to send a painting of Indians to the Taos and Santa Fe artists show at the museum but Wores never did.

SUNDAY, SEPTEMBER 9:

❖ arrives in Taos and is visited by artist Julius Rolshoven.

❖ visits Taos Pueblo for first time. Made a deal with a young Indian, Ralph Martinez, who has team of two horses to work for Wores for $1.50 per day. The Indian will pose for paintings, get other models, and take him places.

❖ has tea at Rolshoven's home and meets *"nearly all the artists and they are a fine lot...and willing to help in every way."*

❖ after one night at Columbian Hotel, Taos, plans to move the next day into room at the home of the Leathermans, a couple from Pittsburgh.

MONDAY, SEPTEMBER 10:

❖ made first painting in Taos, a portrait of his hired Indian.

❖ noticed wildflowers on road to Pueblo he wanted to paint later.

❖ attends party for many artists at home of Mr. and Mrs. Gusdorf (he runs general store in Taos that has been there for forty years). Talks of Blumenschein making good music on the violin, as well as drumming in a march around the dining room, impatiently waiting for dinner to be served.

WEDNESDAY, SEPTEMBER 12:

❖ wrote of making his painting of his Indian dressed in a white mantel standing by the side of his horse with his hand shading his eyes while looking intently into the distance. *"It suggests an outpost watching for the enemy...I have the Indian finished and the horse will be painted tomorrow morning."* While the modeling of figure and horse are good, the observation of the sunlight is totally wrong as the Indian shades his eye with the sun coming from his back.

THURSDAY, SEPTEMBER 13:

❖ talks of taking eight to ten photographs. *"One of these should make a very attractive picture."*

❖ indicates he would like to return to Taos next summer (but never does.).

FRIDAY, SEPTEMBER 14:

❖ talks of yesterday visiting Blumenschein's studio for a social gathering of artists.

❖ indicates that all artists from last night's party *"were expected to be at the Phillips studio at 2 o'clock as a moving picture outfit wished to take some pictures. We all gathered at that time and everybody dressed up in an Indian costume. I was given a blanket and moccasins and had it draped over me Taos fashion. Each of the artists was first placed before the camera and his individual picture taken. I was told to act the part of a dignified chief so I gazed about me in what I thought was a very haughty air. After that we all joined in a sort of war dance and the performance was over."*

❖ plans painting for next day by asking *"my Indian"* to *"get an Indian girl and I will paint a picture of her gathering these wild plums."*

SUNDAY, SEPTEMBER 16:

❖ relates that Julius Rolshoven came over to visit him and he *"was very much interested in the photographs of my Indian pictures and my pictures of Japan in the Century-Scribner's."*

❖ tells the story of he and his Indian, who *"seems to know all the Americans and other residents of Taos and can tell me all about them. Yesterday while I was at the Pueblo I noted a rather attractive young woman, an American, and a young man wondering about the place. They had evidently walked out from the town. While we were driving back to town we met them half way back. They were standing by the road-side with bunches of wild plums which they were eating. After we passed them I said to the Indian, Who are those people? He answered, Oh I don't know. I know that that young woman was married about a year ago and that is not her husband that is with her. So you see, even Indians are not above gossip."*

WEDNESDAY, SEPTEMBER 19:

❖ *"In the afternoon I worked about four hours on the other Pueblo picture and succeeded in finishing that one also. Just after I had finished I met Mr. and Mrs. Rolshoven and Mr. Blumenschein who came out with a moving picture company. They had three or four automobiles and they gathered in about ten Indians and went out into the woods to take some pictures. A little later it began to rain and Mr. and Mrs. Rolshoven passed by my place so they came in for shelter. I showed them the work I had done and they seemed very enthusiastic and praised them very highly. Mr. Rolshoven said I was the only artist here who was going about it the right way – that is spending so much time at the Pueblo."*

THURSDAY, SEPTEMBER 20:

❖ *"The great event of the year, the Indian Fiesta on San Geronimo day, the 30th of this month, is near at hand and the place will be crowded with visitors and every house in town will be filled to overflowing...I asked the Indian governor of Taos if I would*

be permitted to take photographs. He said for a fee of 2 dollars I could take all the pictures I wanted...The Indian women are all hard at work cleaning and repairing the houses for this great event...At present there are very few of the inhabitants in town during the day as they are all harvesting their crops."

TUESDAY, SEPTEMBER 25:

❖ talks of using the sister of his Indian as the model for the painting of a woman and small girl picking plums. He took a half a dozen photographs of the little girl and plans to use them in other pictures.

WEDNESDAY, SEPTEMBER 26

❖ describes the fancy dress ball he attended previous night at the moving picture hall for the benefit of the Game and Fish Association, of which Mrs. Leatherman is one of the moving spirits. *"All the artists were there and they made it a success with their costumes. Mr. Sharp was in a Mexican costume and his wife made a fine Indian. The Rolshoven's niece, appeared as a cow girl. Walter Ufer came as an old red faced apple woman. There were some real Indians present – they go everywhere and they were very much amused at the imitation Indians."*

FRIDAY, SEPTEMBER 28:

❖ he witnesses a funeral procession. *"My Indian informed me in the morning that his uncle died last night and the funeral would take place early in the afternoon. When I returned from my work I passed the funeral procession going to the cemetery. One of the party carried a rude cross and he was followed by a Roman Catholic priest who lives here in town. The woman were all wailing and I could hear them until they reached the old Pueblo church."*

❖ after about four hours of painting, he strolls *"around the Pueblo taking in all the new arrivals, Apache, Cherokee, and other tribes of Indians who were coming in from all directions. Lots of Mexicans too and they all have something to sell...What interested me more than the dance was the crowds. The Indians were all dressed in their best and in bright colors...Along towards five o'clock automobiles by the dozen arrived all loaded down by visitors from all directions who come to see the 'Sunset Dance.'"* Afterwards *"automobiles began racing along the road. The dust was so think you couldn't see ten feet ahead."*

SUNDAY, SEPTEMBER 30:

❖ *"Well, the great Fiesta is over. I spent the whole day at the Pueblo...The principal event of the morning was a series of races between the two sections of the Pueblo, one lying to the north and other on the south side of the stream. The men, the runners, were clad only In a breech cloth and their bodies were painted in various designs...The race was over a course of about a hundred yards and the effect reminded me of a*

Roman amphitheater when tier after tier rose up from the arena. One side of the track was the Pueblo and the other side was crowded with spectators...Everybody seemed to be having a good time and the Taos natives were acting as hosts and apparently keeping open house for several times when I went to my Indians house it was filled with stranger Indians and Mexicans who were being fed.

In the afternoon there was a climbing contest. A high pole was erected in the middle of the Pueblo and suspended from the top was a sheep, bags of fruits and a lot of other things. A lot of Indians attempted to climb the pole but only a few succeeded and they received the presents."

THURSDAY, OCTOBER 11:

❖ *"Mr. Phillips, one of the artists who lives here, came...to see my work and was very well pleased with it. His favorite was the girl in the cornfield. He thought it was wonderful how much I had accomplished in the time that I was here and said I had gone about it in the right way. I was very glad of his approval for he is one of the more conservative artists and does not look at them from the view of an extremist."*

MONDAY, OCTOBER 15 (HIS LAST LETTER HOME):

❖ *"This morning I did my last work at the Pueblo. I painted a canvas of a girl in full sunlight sitting on a ladder with a pumpkin in her arms...When I returned I told Ralph, my Indian, that this would be the last trip and he seemed quite, sad, said he thought I had proved a very good friend to him and that he hoped I would come back."*

❖ *"Well the light is going and day is coming to an end so I will say good night to my little sweetheart and with much love and many kisses and many hugs, etc. etc., I am as ever your devoted and loving, Theodore."*

THEODORE WORES
IN THE SOUTHWEST

STEPHEN BECKER AND PAMELA YOUNG LEE

Ethnography on Display: The Panama-Pacific International Exposition

Postcards of the "Indian Village" in the "Fun Zone" at the Panama-Pacific International Exposition, 1915. Private Collection.

Wores' first introduction to the Native Peoples of the Southwestern United States came not from a trip to Arizona or New Mexico, but by visiting the Panama-Pacific International Exposition in his home city of San Francisco. The "PPIE," as it has come to be known, was announced as a celebration of the completion of the Canal, but truly was a glorification of the return of San Francisco from the ashes of the 1906 Earthquake and Fire.

The PPIE featured numerous pavillions and large scale exhibitions of art and industry set in a huge expanse of Beaux Art palaces and plazas, magically illuminated at night. Herb Caen, the San Francisco *Chronicle*'s noted columnist, noted years later "The '15 Fair...was a gamble that turned into a dazzling success, built on land dredged from San Francisco Bay. Only nine years after a devastating earthquake – one of the worst in history – San Francisco was out to show the world that it had bounced back."

The Fair's designers and leaders sought to project a sophisticated style and ambience to the Exposition, centered on the Tower of Jewels at the Fair's great central gate and balanced by huge buildings representing each of the 48 States and the territory of Hawaii. Despite the war raging in Europe, 24 countries were represented. In addition there were eleven main exhibit palaces, including the Palace of Fine Arts at the Fair's western boundary, the Manufacturers Palace, the Palace of Horticulture, the Palace of Varied Industries, the Palace of Machinery and the Palace of Liberal Arts.

But on the eastern boundary of the Fair was an altogether different sort of experience where the risqué, the odd and the exotic were on display along with fun and frivolous rides and entertainments. "The Joy Zone," or as it was more commonly known, "The Zone," had sideshow games and refreshments from around the world, as well as a five-acre working replica of the Panama Canal and a model of Yellowstone Park with an erupting Old Faithful geyser. The Atchison, Topeka & Santa Fe Railway featured their Grand Canyon of Arizona exhibition, a ride through a huge re-creation of the Grand Canyon. On the roof of the exhibit stood a faux Indian pueblo, peopled by Pueblo and Navajo families from Arizona and New Mexico who demonstrated crafts and posed for the tourists.

The re-creations at the PPIE were in the same style as those created at the Grand Canyon by the Railroad and the Fred Harvey Company, which ran the Railroad's hotels and craft shops along their train routes in the Southwest. Designed by such architects as Mary Colter, these Southwest-themed structures evoked a fantasy of the Indian and Spanish past, coupled with present-day traditional arts. Such displays of people had been a part of world's fairs and expositions since at least the middle 19th century, and it was a simple leap to creating "living environments" featuring native artisans at the Harvey hotels. Indeed, such "displays" continue to this day; on the main plaza in Santa Fe, for example, the practice of local Pueblo Indian artisans selling their works directly to customers, and being "on display" themselves, has become a regulated program at the Palace of the Governors, the history museum of the Museum of New Mexico.

These quasi-ethnographic displays were a central marketing tool and attraction, and a major feature in the Santa Fe Railroad's serious entry into the business of tourism in the late 19th and early 20th century. The rail line ran from Los Angeles to Chicago and Cleveland, but in Arizona and New Mexico, grand hotels were built along the way, including sidetrips to the magnificent El Tovar at the Grand Canyon and the venerable La Fonda in Santa Fe. "From Cleveland to the Coast," the Railroad's tourist brochure boasted, "3,000 miles of hospitality." At every stop, just as at the PPIE, American Indians lived and worked, wove blankets, made pottery and jewelry, and posed for photographs.

It was here that San Francisco artist Theodore Wores was introduced to the romance of the American Southwest, infecting him with a curiosity to travel by rail to the "real" Southwest. As he had so often been in the past, he was inspired to paint portraits of these "exotic peoples." Wores added an important step to the process: his camera recorded his models in poses he set up, allowing him time later in his studio to transfer his numerous PPIE photographs into the first part of this three-year series of portraits and landscapes of Southwest American Indians. In posing his subjects, these photographs confirm Wores' dependence on the camera to assist him in his work, although he also made study sketches, and perhaps worked plein air, although it is impossible to know if Wores was allowed to set up his paints and canvas at the PPIE. Wores' photographs made at the PPIE in turn became more than 20 paintings. Most of the paintings were executed in 1915, but a few were painted later from his photographs and sketchbooks.

The poses Wores made emphasized his notions of traditional life. As Burton Benedict describes in his landmark work, *The Anthropology of World's Fairs: San Francisco's Panama Pacific International Exposition of 1915*, displays of people historically fit into four categories: people as

technicians, people as trophies, people as specimens or scientific objects, and people as curiosities or freaks. Excluding the latter category -- which Benedict reserves for such attributes as dwarfishness, enormous girth, or "talents" such as sword swallowing, firewalking or glass eating – the other three categories seem to fit both the presentation at the PPIE and Wores' usual style of depicting native peoples.

Further emphasizing these points, Benedict notes that there were few displays of living Native Americans in the "serious" parts of the exposition; instead, paintings and sculpture were the norm – most famously James Earle Fraser's "The End of the Trail," with the slumped and defeated Plains Indian on his horse, tired, although still noble. It was in the "fun" amusements section of the PPIE that living exotic peoples were on display, including the Southwestern Indians that Wores chose to paint. Taken out of the context of the PPIE, the scenes and depictions were so "true to life" that Wores' titles for the series of PPIE paintings give no clue that they were created in fake settings with imported models.

Panama-Pacific International Exposition
San Francisco, 1915

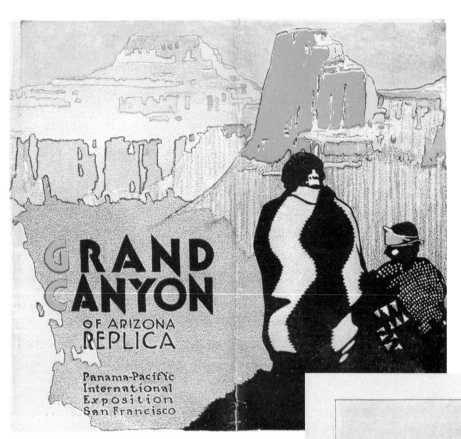

"Grand Canyon of Arizona Replica" brochure, 1915,
Atchison, Topeka and Santa Fe Railway,
Courtesy of the Bancroft Library, University of
California, Berkeley, pF869.S3.95.G.66.1915

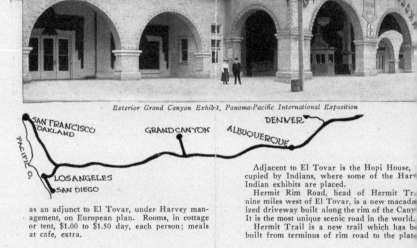

Exterior Grand Canyon Exhibit, Panama-Pacific International Exposition

as an adjunct to El Tovar, under Harvey man-
agement, on European plan. Rooms, in cottage
or tent, $1.00 to $1.50 day, each person; meals
at cafe, extra.

Adjacent to El Tovar is the Hopi House,
cupied by Indians, where some of the Harv
Indian exhibits are placed.

Hermit Rim Road, head of Hermit Tra
nine miles west of El Tovar, is a new macada
ized driveway built along the rim of the Cany
It is the most unique scenic road in the world.

Hermit Trail is a new trail which has be
built from terminus of rim road to the plate

The Santa Fe Railroad and its partner, the Fred Harvey Company of Harvey House fame, used their exhibit at the PPIE, as well as an even larger exhibit, The Painted Desert, at San Diego's Panama-California Exposition, to promote travel to the American Southwest. The Grand Canyon of Arizona exhibit at the PPIE was spectacular. Future theme-park creators had nothing on Santa Fe Railway promoter, William Sessor, who was in charge of the San Francisco exhibit.

The Grand Canyon of Arizona, at the Exposition, is viewed from observation-parlor cars, moved by electricity on an elevated trestle along the rim. The observer can see seven of the most distinctive points on the Canyon, and over one hundred miles of the general panorama. The ride lasts nearly fifteen minutes. All resources of modern science in electrical effects have been exploited, and the best talent of the world was engaged in the work of reproduction.

<div align="right">

"Grand Canyon of Arizona Replica, Panama-Pacific International Exposition, San Francisco," exhibit brochure, 1915, Atchison, Topeka & Santa Fe Railway

</div>

Atop the main building that held the huge Grand Canyon model, the exhibit's creators built a pueblo village. To add the final touch of authenticity and vitality, twenty Indian families from in and around the pueblo of Isleta were brought to live in the faux pueblo at the PPIE. The Indian families dressed in native clothing and jewelry, and demonstrated indigenous arts and crafts.

... some twenty families....live exactly as they live at home, weaving baskets or blankets, rolling corn for meal in queer stone troughs exactly as was done by their fathers and their fathers' fathers for untold generations.

<div align="right">

"The Grand Canyon of Arizona at the Panama-Pacific Exposition," The Santa Fe Magazine, July 1914.

</div>

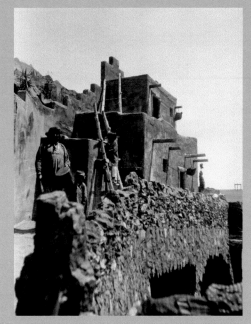

Scene at The Indian Village, PPIE 1915

Perhaps most significantly for the exhibition at the PPIE, transplanted Native Americans posed for the visitor's camera and the occasional artist's canvas.

On the roof of the entrance building was a large and realistic pueblo, which was occupied by Indians and formed one of the best features of the display. With its rock trails, ladder approaches and evidences of Indian arts scattered about, it added a most interesting element to the Zone itself. Artists were glad to avail themselves of the privilege of making studies of it instead of visiting the reservations for that purpose.

<div align="right">

Frank Morton Todd in *The Story of the Exposition: Being the Official History of the International Celebration Held at San Francisco in 1915*, 1921.

</div>

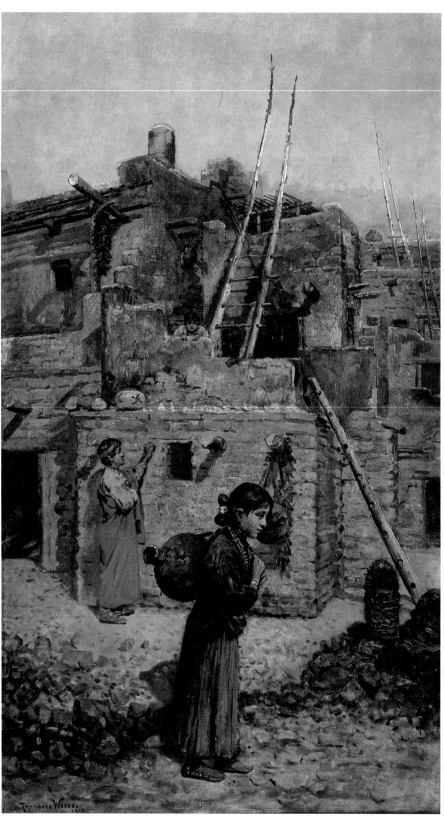

Hopi Architecture
1915
Theodore Wores
oil on canvas
History Collections, Natural History Museum
of Los Angeles County

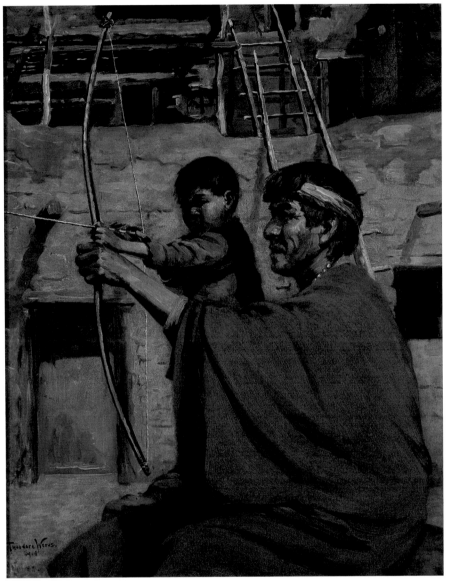

A Lesson in Archery
1915
Theodore Wores
oil on canvas
History Collections, Natural History Museum
of Los Angeles County

Navajo Girl Carrying Corn: Hogan Behind
1917
Theodore Wores
oil on canvas
History Collections, Natural History Museum
of Los Angeles County

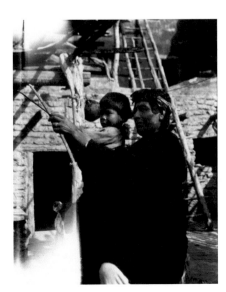

Models for "A Lesson in Archery," PPIE
1915

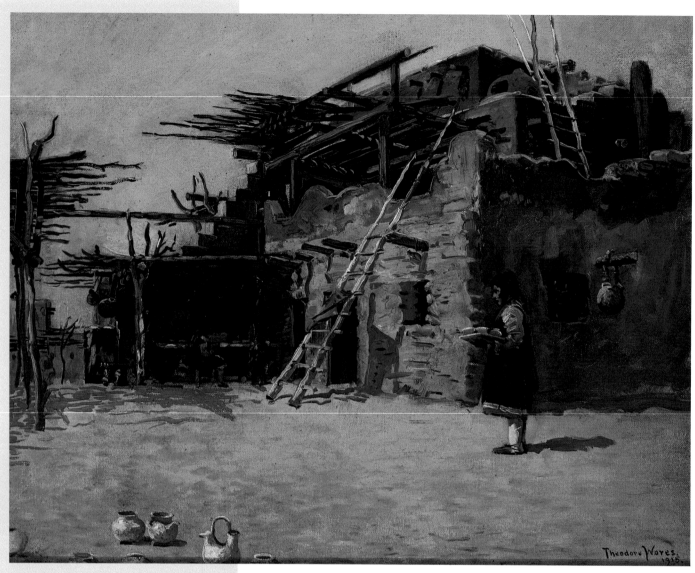

A Pottery in Hopi Land
1915
Theodore Wores
oil on canvas
History Collections, Natural History Museum
of Los Angeles County

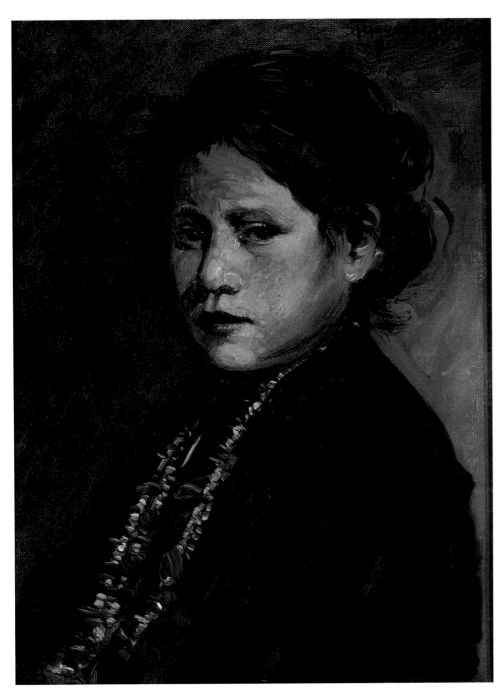

A Navajo Maiden
1915
Theodore Wores
oil on canvas
History Collections, Natural History Museum
of Los Angeles County

The Santa Fe Railway transported dozens of Native American families to San Francisco to demonstrate native arts and handicrafts at its Grand Canyon of Arizona exhibit at the PPIE. Among the families of demonstrators were renowned weavers Elle and Tom of Ganado, Navajos who worked for the Harvey Company at El Tovar. At the concurrent Panama-California Exposition taking place in San Diego, famed potter Maria Martinez was brought to the Santa Fe Railway's Painted Desert exhibit to demonstrate pottery making.

In an interview with art historian Lewis Ferbraché, Carrie Bauer Wores related her late husband's enchantment with the Grand Canyon of Arizona exhibit, and with the demonstrations of Native American crafts such as basket weaving, pottery making, and rug weaving in particular. Ferbraché writes, "A beautiful young Indian girl was engaged in the latter handicraft, and one of his finest paintings, The Navaho Rug Weaver shows her at work in the Indian exhibit."

Until recently, it was thought that this painting was the only one Wores painted of the PPIE. However, research for this exhibition and catalog revealed that paintings previously assumed to have been executed during an excursion to the Southwest in the fall of 1915 were actually depictions of scenes found at the Santa Fe Railway's Grand Canyon of Arizona exhibit at the PPIE in San Francisco in 1915.

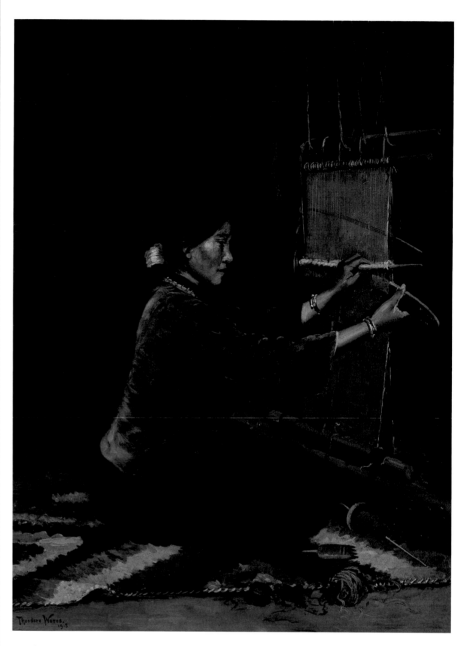

Navajo Rug Weaver
1915
Theodore Wores
oil on canvas
History Collections, Natural History Museum
of Los Angeles County

Sketch for "Navajo Rug Weaver"
1915
Theodore Wores
graphite on paper
Courtesy of Fred M. Levin

Panama-Pacific International Exposition, San Francisco, CA
1915
gelatin silver print
Special Collections, University of Arizona Library,
Fred Harvey Collection, 11-2-2

Famed Navajo weaver Elle of Ganado (Red Woman) can be seen in
this photograph of the weaving demonstration at the Grand Canyon
of Arizona exhibit. She is in the center of the photograph facing the
loom with her back to the camera. Her husband, Tom of Ganado
(Mail Carrier), is also in this photograph standing next to Elle and
facing outward. Tom was fluent in English, Spanish, Navajo and Hopi
languages and often translated for Elle, who only spoke Navajo.

Sketch of Weavers, PPIE
Theodore Wores
circa 1915
graphite on paper
Courtesy of Fred M. Levin

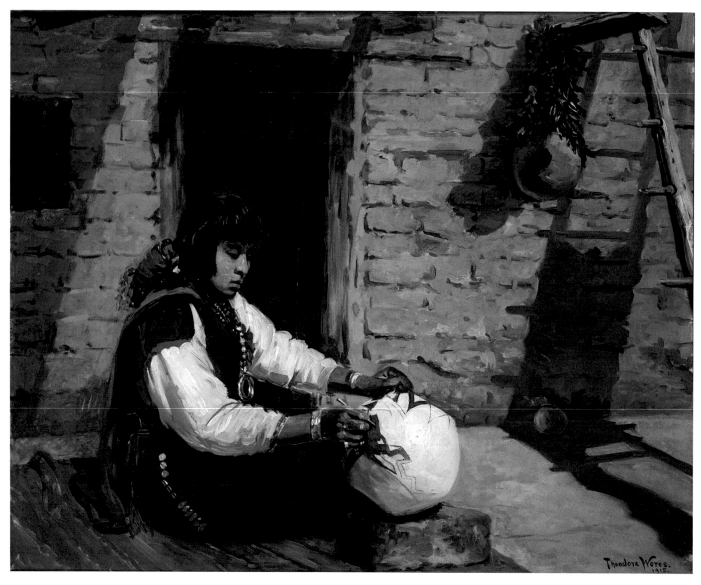

Painting Pottery, Acoma, New Mexico
1915
Theodore Wores
oil on canvas
History Collections, Natural History Museum
of Los Angeles County

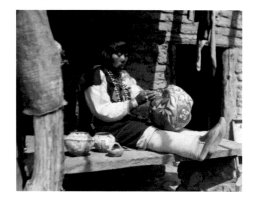 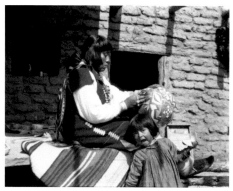

Two photographs of the model for
"Making Pottery," PPIE
1915

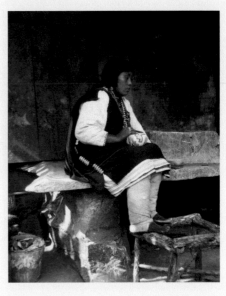

Female Model for "The Connoisseur," PPIE
1915

The Connoisseur, Acoma, New Mexico
1915
Theodore Wores
oil on canvas
History Collections, Natural History Museum
of Los Angeles County

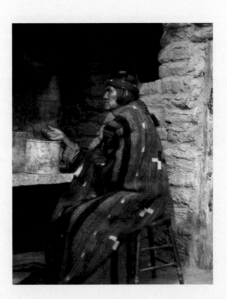

Male Model for "The Connoisseur," PPIE
1915

Sketch for "The Connoisseur"
1915
Theodore Wores
graphite on paper
Courtesy of Fred M. Levin

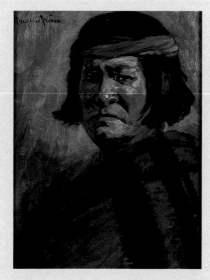

A Citizen of Acoma
1915
Theodore Wores
oil on canvas
History Collections, Natural History Museum
of Los Angeles County

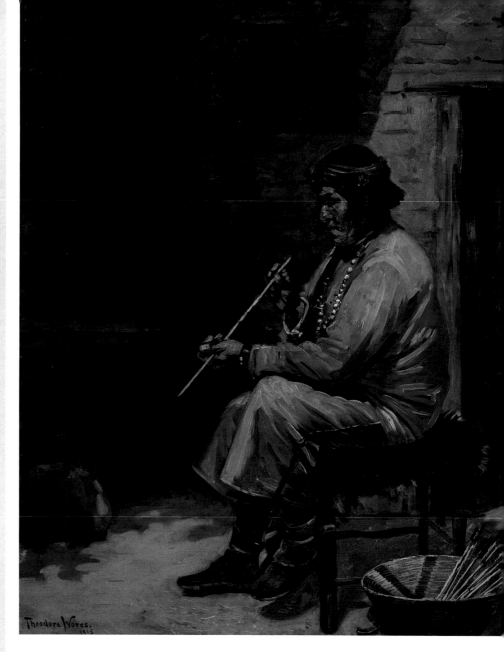

Arrow Maker of Acoma
1915
Theodore Wores
oil on canvas
History Collections, Natural History Museum
of Los Angeles County

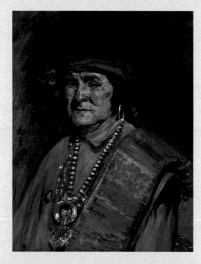

A Patriarch of Acoma, New Mexico
1915
Theodore Wores
oil on canvas
History Collections, Natural History Museum
of Los Angeles County

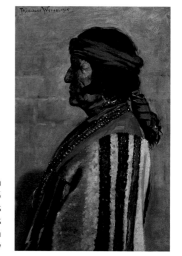

Chief of the Acoma
1915
Theodore Wores
oil on canvas
History Collections, Natural History Museum
of Los Angeles County

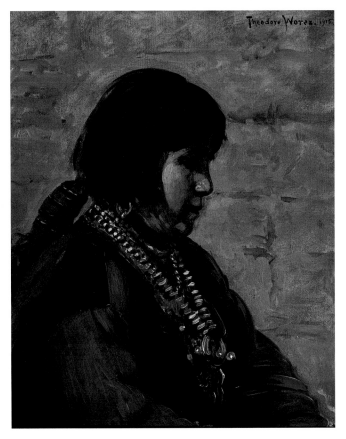

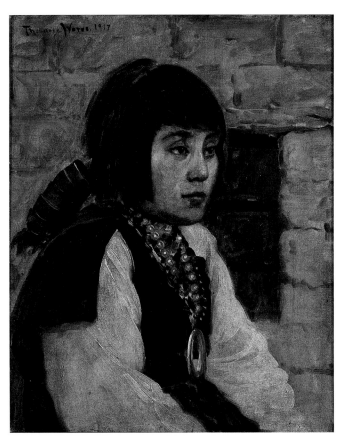

Acoma Woman, Silver Necklace
1915
Theodore Wores
oil on canvas
History Collections, Natural History Museum
of Los Angeles County

A Hopi Maiden
1917
Theodore Wores
oil on canvas
History Collections, Natural History Museum
of Los Angeles County

Mother and daughter at the Indian Village,
PPIE
1915

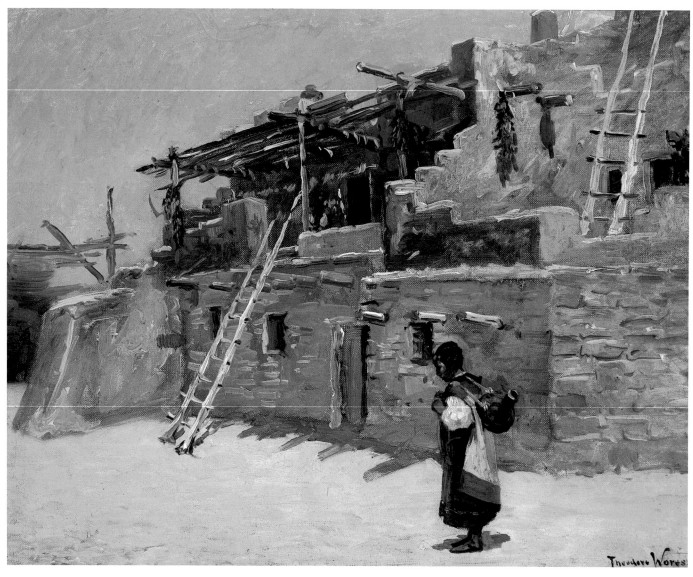

Pueblo and Water Carrier
1917
Theodore Wores
oil on canvas
History Collections, Natural History Museum
of Los Angeles County

This painting, with a background
similar to those of other
paintings from the PPIE, was
probably painted from Wores'
photographs many months after
the Native American models left
San Francisco and returned to
Arizona and New Mexico.

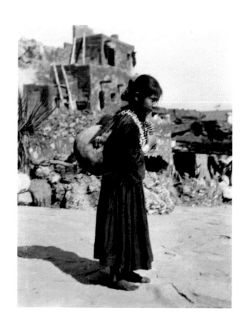

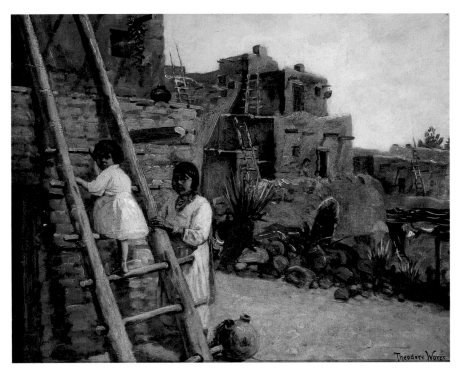

A Hopi Elevator
1917
Theodore Wores
oil on canvas
History Collections, Natural History Museum
of Los Angeles County

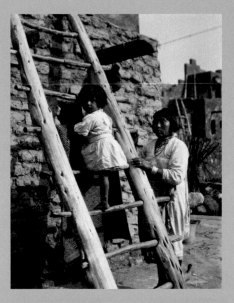

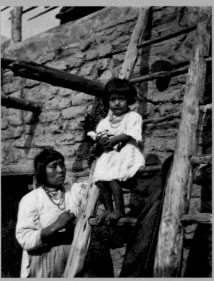

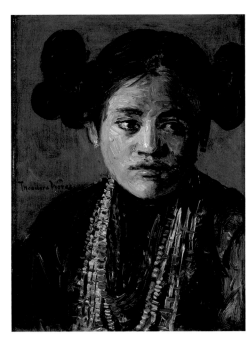

The Beaded Necklace
nd (circa 1915)
Theodore Wores
oil on canvas
History Collections, Natural History Museum
of Los Angeles County

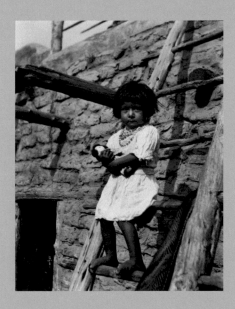

Three photographs of poses for
"A Hopi Elevator," PPIE
1915

The little girl in this portrait, along with a little boy who may be her brother, appears in numerous photographs taken by Wores at the PPIE. Depending on the photograph, the little girl appears amused, shy, bored or downright impish – much like any toddler repeatedly asked to pose. In "A Little Mother of Acomita," the child is portrayed holding an Arapaho-style doll. However, in the photographs, the model is holding a Japanese Ichimatsu doll or Japanese "play doll." The Japan Beautiful exhibit was very close to the Grand Canyon of Arizona exhibit in The Fun Zone at the PPIE. It is likely the Japanese doll was a souvenir from this neighboring exhibit. As he painted, Wores merely substituted a doll that he felt was more culturally appropriate.

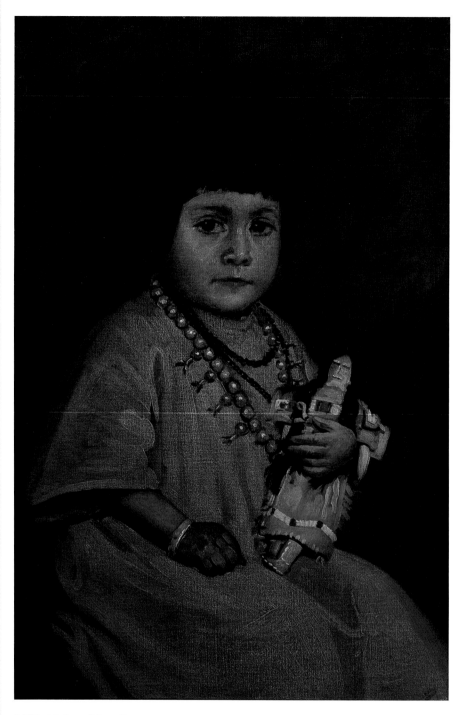

A Little Mother of Acomita
nd (circa 1915)
Theodore Wores
oil on canvas
History Collections, Natural History Museum
of Los Angeles County

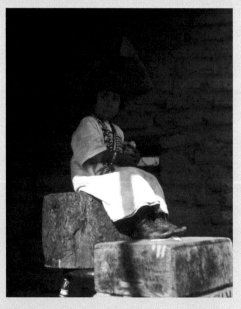

Model for "A Little Mother of Acomita," PPIE I
1915

Model for "A Little Mother of Acomita," PPIE III
1915

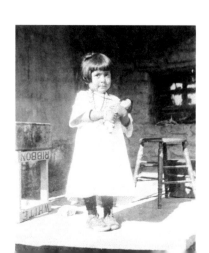

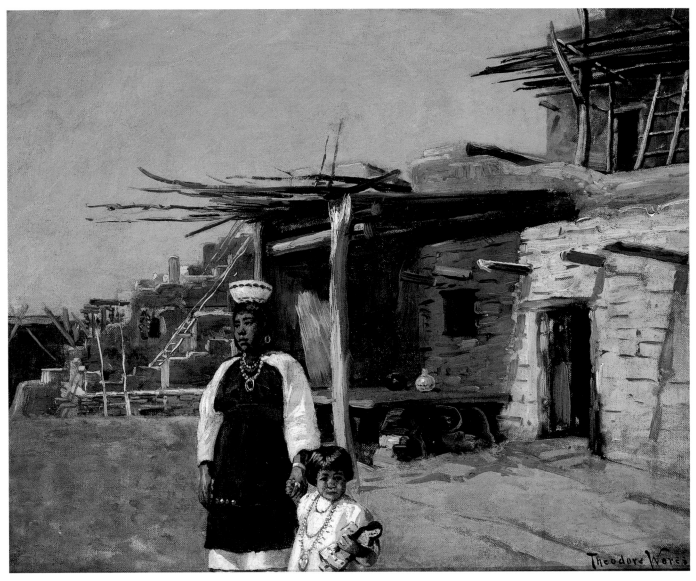

A Hopi Mother and Child
1917
Theodore Wores
oil on canvas
History Collections, Natural History Museum
of Los Angeles County

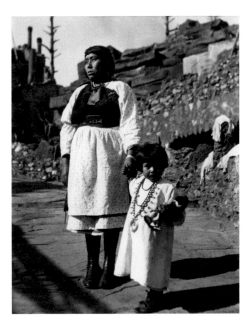

Mother and daughter modeling for
"A Hopi Mother and Child," PPIE
1915

There are two mothers with children in this painting from the PPIE. It is likely that all the figures in this painting were done from photographs. The mother and child in the foreground were captured by Wores in several of his snapshots at the PPIE. The mother and child in the background are the same figures as in "Hopi House, El Tovar, Grand Canyon of Arizona," and the adult female figure appears in the painting to the right, "A Pueblo of the Southwest."

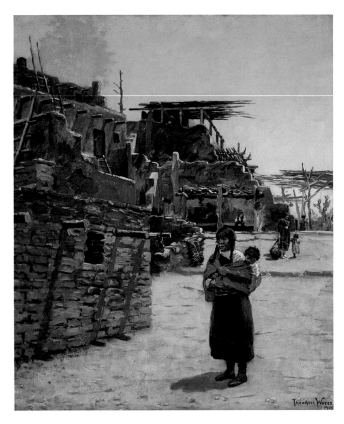

Mother and Child, Acoma
1915
Theodore Wores
oil on canvas
History Collections, Natural History Museum
of Los Angeles County

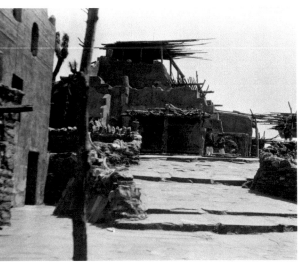

Scene from the Indian Village, PPIE
1915

A Pueblo of the Southwest
1917
Theodore Wores
oil on canvas
History Collections, Natural History Museum
of Los Angeles County

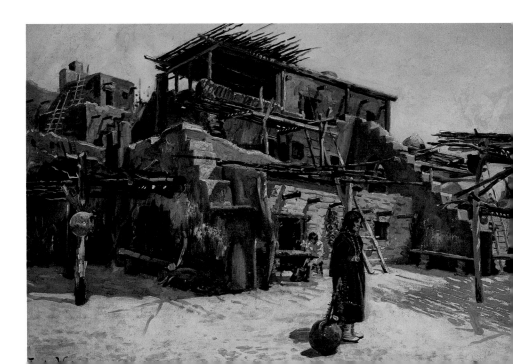

Sketch of the Grand Canyon
circa 1915
Theodore Wores
graphite on paper
Courtesy of Fred M. Levin

"Sketch of the Grand Canyon" was probably made by Wores at the Panama-Pacific International Exposition in 1915, presaging his decision to travel to see the real canyon the next year. The Santa Fe Railway and one of its advertising executives, William Sessor, hired scenic artist Walter W. Burridge to create accurate murals of the Grand Canyon to help reproduce the Canyon on reduced scale at the PPIE using forced perspective and other theatrical devices. Unfortunately, Burridge died before the commission was completed. The contract was completed with the help of other artists using Burridge's preliminary sketches, color palettes and research. The finished product was an impressive replica of the Grand Canyon that visitors traveled through in a railway car.

The tourist through this replica of the cañon will travel in a de luxe coach which will accommodate thirty-five to forty passengers and will differ from an ordinary coach only in that an outlook may be had from one side only. The cars will stop at seven different stations, which were chosen because they come as nearly as possible to embracing all the different aspects the cañon presents."

"The Grand Canyon of Arizona at Panama-Pacific Exposition," The Santa Fe Magazine July 1914, pp. 49-50

Painting Tourism:
El Tovar, Hopi House
and The Grand Canyon

One can surmise that the Santa Fe Railroad would have been very pleased with Wores' experiences with Native Americans at their PPIE exhibition, because the next year the painter traveled with his wife to stay at the Harvey House complex on the Canyon's South Rim, taking in the scenery, and painting portraits of the Pueblo and Navajo Indians ensconced at the hotel for the benefit of the tourists. In addition, Wores painted a few canyon landscapes from vantage points at the nearby Grand Canyon overlooks.

Some fifteen years before, the Santa Fe Railway had rebuilt sixty-five miles of defective track between Williams, Arizona and the Grand Canyon, effectively opening the gates to one of the seven wonders of the natural world. In November 1904, the Santa Fe opened the luxurious Fred Harvey hotel El Tovar on the south rim of the Canyon. The Santa Fe's trains pulled into a station just steps from El Tovar's front door, and directly across the plaza from El Tovar was Fred Harvey's gallery and salesrooms for Native American arts, opened on January 1, 1905. Entitled "Hopi House" and designed by Mary Colter, an architect who became closely identified with the Grand Canyon and the Fred Harvey Company, the shop featured expert weavers, silver-smiths and pottery makers, whose wares were available for sale.

The Fred Harvey Company operated restaurants, newsstands, gift shops, and hotels for the Atchison, Topeka and Santa Fe Railway beginning in 1876. The basis for Harvey's success was that he pro-vided an attractive, clean restaurant environment for train travelers while at the same time providing moderately priced, appetizing meals that could be consumed within the limited time allotted during the train stops – usually no more than thirty minutes. The arrangement between the Fred Harvey Company and the Santa Fe Railway was that the Santa Fe would build and own the station restaurants and hotels while the Harvey Company would manage them.

Observing the tourists' interest in purchasing native arts and crafts from the local Indians at the train stops, the Fred Harvey Company opened an "Indian Department" in 1901 and began marketing Indian

handicrafts. The company became very closely tied with the promotion of the Southwest through the display and merchandising of some of the finest Native American art to be found along the lines of the Santa Fe Railway. Collections assembled by the Harvey Company now form the foundations of several important museum collections, including the Heard Museum, the Nelson-Atkins Museum of Art, the Field Museum of Natural History, and the National Museum of the American Indian.

By the time of Wores' travels to Arizona in 1916, the effects of the PPIE had struck a solid chord with wealthy, traveling Americans seeking the exotic just a few days' ride from their homes in the Midwest and West Coast. According to author Arnold Berke in *Mary Colter: Architect of the Southwest*, "Tourism to the Grand Canyon, which was already rising, surged even more as a result of Santa Fe/Fred Harvey promotions at the 1915 fairs. Annual visitation, which had numbered less than 1,000 prior to the railroad's arrival in 1901, topped 100,000 in 1915 – 6,000 more than the combined total of visits that year to Yellowstone, Yosemite, and Glacier National Parks."

Berke also describes how Native American artisans were such an important part of the Harvey company's tourist attractions, especially at the Grand Canyon: "Hopi House was a direct outgrowth of the popular 'anthropological' exhibits of Native Americans, complete with dwellings, that Harvey and others had set up at world's fairs and other expositions of the day and would continue to do. In this case, however, the 'exhibit' was permanent and over the years would grow into one of the most-visited sites at the Grand Canyon."

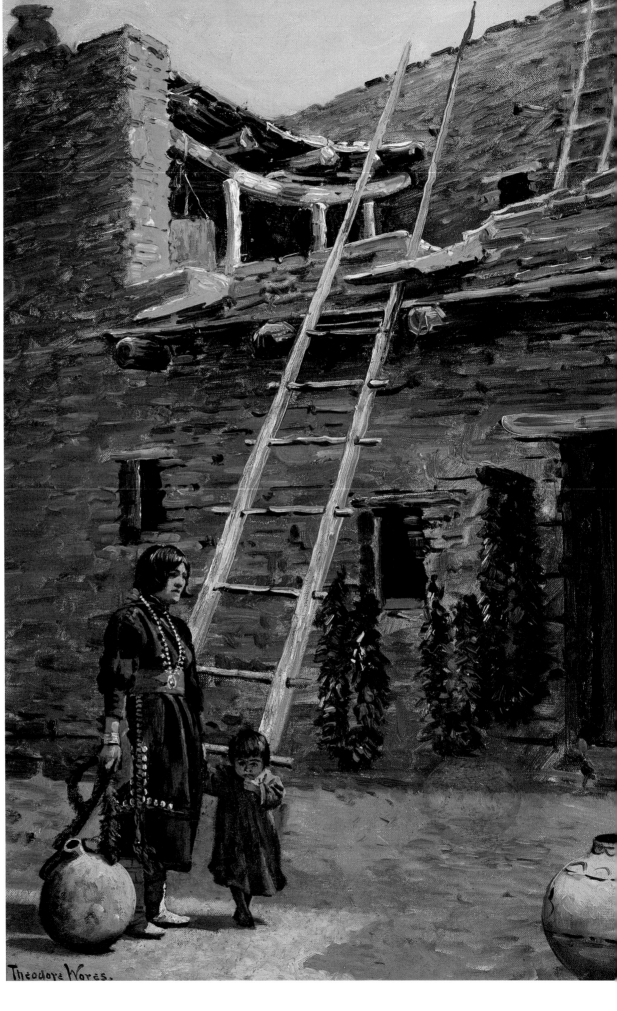

Hopi House, El Tovar, Grand
Canyon of Arizona
1916
Theodore Wores
oil on canvas
History Collections,
Natural History Museum of
Los Angeles County

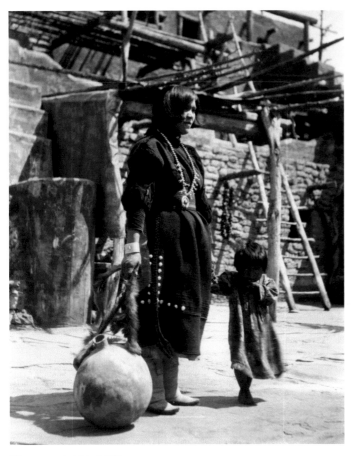

Woman and child at PPIE
1915

One can speculate that Theodore Wores and his wife stayed at Fred Harvey's El Tovar Hotel overlooking the Grand Canyon in the fall of 1916. There were other accommodations available at the Canyon, but Wores appears to have painted this scene of Hopi House from the balcony of the third floor suite on the west end of El Tovar, looking northeast toward Hopi House.

Although the painting makes it look as though the woman and child are standing on the ground in front of Hopi House, they are actually placed on a second floor patio. Here, Wores creatively combined his painting of Hopi House with figures from his photographs of a woman and child at the 1915 PPIE.

Hopi House, Grand Canyon, Arizona
September 1, 1916
Photographer unknown,
possibly Carrie Bauer Wores

This photograph shows artist Theodore Wores at work painting "A Hopi Water Carrier" at Hopi House in the fall of 1916. The reverse of the photograph identifies the model as "Grace," and the woman watching as "Mrs. W. H. Sable."

The young Hopi model in this painting also appears in the painting "Hopi Basket Maker." The young girl is standing outside Hopi House near one of the exterior stairways on the southwest corner of the building. Through Wores' notes, we know that she was called "Grace," although this could easily be an Americanized name she adopted while working at the Grand Canyon.

Hopi Girls
29 August 1916
Photographer unknown,
possibly Carrie Bauer Wores

The young girls posed outside of Hopi House are identified, from left to right, as Grace, Polly, and Amy. Nothing more is known about them at this time.

A Hopi Water Carrier,
El Tovar, Grand Canyon of Arizona
1916
Theodore Wores
oil on canvas
History Collections, Natural History Museum
of Los Angeles County

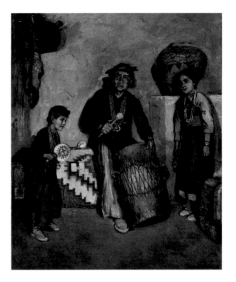

First Lesson of the War Dance
1916
Theodore Wores
oil on canvas
History Collections, Natural History Museum
of Los Angeles County

Photographs of the models in this painting have not been located, but given the flatness of the figures and the cramped quarters in this particular area of Hopi House, there is a high probability that the painting was executed with the aid of photography. It is possible that the models are from the Panama-Pacific International Exposition, as were the models for "Hopi House, El Tovar, Grand Canyon of Arizona." Native American demonstrators and artisans were brought to both the PPIE and Hopi House to perform for visitors.

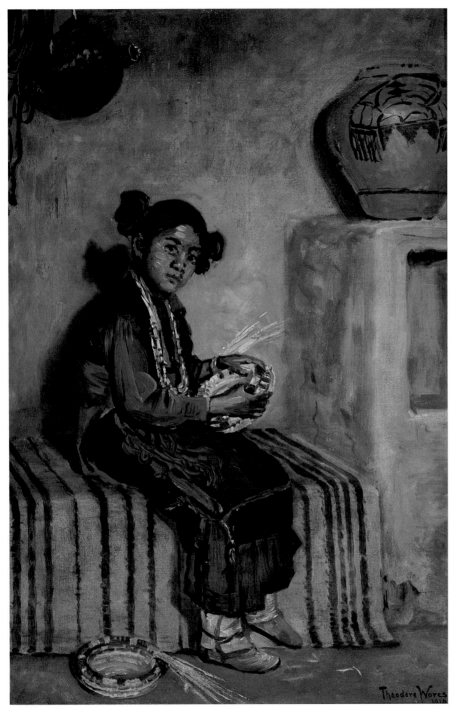

Hopi Basket Maker
1916
Theodore Wores
oil on canvas
History Collections, Natural History Museum
of Los Angeles County

This painting and "First Lesson of the War Dance" each depict the same first-floor location inside Hopi House at the Grand Canyon.

The Grand Canyon of Arizona
1916
Theodore Wores
oil on canvas
History Collections, Natural History Museum
of Los Angeles County

This painting of the Grand Canyon is from the Rim Walk just east of Hopi House, looking west toward Battleship Rock. The flower-strewn path in the bottom left of the painting is several feet below the current Rim Walk trail with its sturdy safety rails.

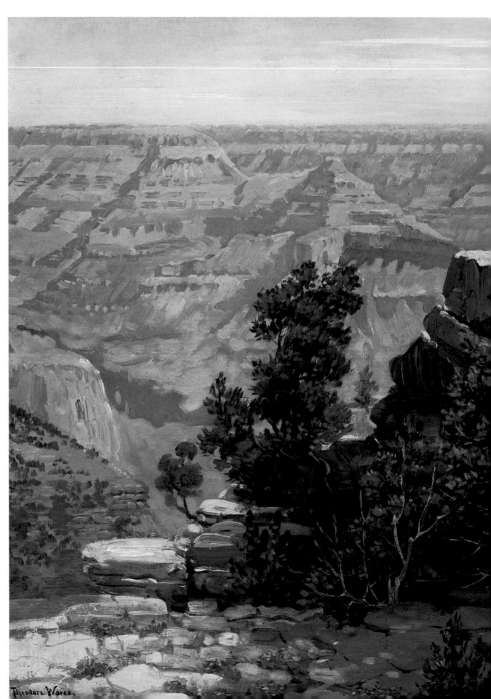

The Grand Canyon of Arizona from El Tovar
1916
Theodore Wores
oil on canvas
History Collections, Natural History Museum
of Los Angeles County

This view of the Grand Canyon is from West Rim Drive (now called Hermit Road) looking northeast, not far from El Tovar and Hopi House.

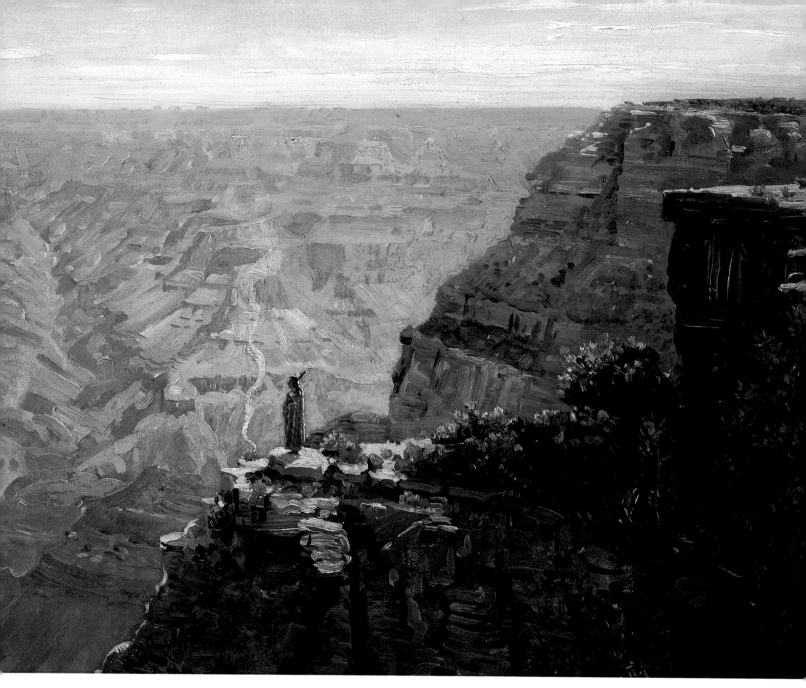

Signal Fire, Grand Canyon
1917
Theodore Wores
oil on canvas
History Collections, Natural History Museum
of Los Angeles County

The location depicted is Bright Angel Canyon looking north from the South Rim of the Grand Canyon, not far from El Tovar and Hopi House. This painting was probably created using photographs taken at the Grand Canyon the previous year. The fanciful inclusion of the Native American figure and the signal fire are artistic license on Wores' part.

Taos, New Mexico

Wores' interest in Southwestern Indians culminated with his historic trip to Taos, New Mexico, in the late summer and early fall of 1917. He traveled alone, but was most anxious to meet up with members of the Santa Fe and Taos arts communities, including a few of his old friends from his student years in Germany. In Santa Fe, the new Museum of Fine Arts was under construction, and in Taos, the community of artists was welcoming and offered great camaraderie and entertainment, as well as helpful instruction and critiques of the paintings Wores would work on during his short but prolific time in the high Southwestern desert and mountain country.

The story of Wores' trip to Taos is recorded in his letters to his wife, which led to the authors and researchers of this exhibition and book being able to locate numerous family members of Wores' principle guide to the Taos Pueblo, Ralph Martinez. As a model and as a host, Martinez relationship with Wores was apparently cordial, if not to some modest degree lucrative for Martinez and his family, who were paid to pose for Wores' camera and canvases. Wores' comments in his letters home that he was advised "never to pay more than 25 cents an hour or a dollar for a morning" to his models; Martinez, nearly always described in Wores' letters as "my Indian," was hired, with his team and two horses, for $1.50 a day, and served not only as a driver, interpreter and model himself, but as an agent for Wores in hiring other models, most likely all members of Martinez' extended family.

Wores' stay in Taos was marked by events that many artists would find stimulating: after four years of planning, the Art Gallery of the Museum of New Mexico was on the verge of opening (November 1917); the Taos Society of Artists was recently founded (1915) and full of vitality; a crew from the New Mexico Publicity Bureau was in Taos filming a travelogue promoting the region; and the annual Taos Pueblo San Geronimo Festival took place during his visit.

Houses at Taos Pueblo
1917

During his stay in Taos, Wores hobnobbed with the artists there. His letters specifically mention sharing artistic discussions, as well as "Dutch luncheons" with Joseph Henry Sharp, Bert Phillips, Ernest Blumenschein, Julius Rolshoven, Irving Couse and Walter Ufer. He also socialized with the artists' patrons, including Burt and Lucy Harwood, Nathan and Maggie Simpson Gusdorf, and Thomas "Doc" Martin. He attended costume parties, participated in the New Mexico promotional film, and observed the San Geronimo festivities at the end of September. One can only surmise that Wores, an elder artist, accomplished and wealthy, was in a way back in his element, among exotic peoples as he was in his early years in Japan and the Pacific islands, with the added luxury and excitement of spending six weeks among the Taos arts community, with its numerous frivolities, picnics, suppers and excursions.

Among Wores' Taos paintings are his most artistically successful in his Southwest series, such as "Wild Flowers of Taos," but, unhappily for viewers today, also some of his crudest and stiff, as in "The Scout," posed by Martinez. Perhaps the artist, now 58 years of age, had lost his touch. But, it is important to recognize that Wores was welcomed as a guest in Ralph Martinez' home, and the artist witnessed Pueblo life from harvest activities to mourning rites. As a result, even the most clumsy of the paintings are a record of a living people, portraits that have meaning today to the people of Taos Pueblo and today's generations of the Martinez family.

"I saw a fine black earthenware jar such as the Indians use for carrying water, quite a large one, in a little shop in town last evening & I bought it for $1.50 (cheap). It will come in very useful in some of my pictures & will be better than having to borrow one every time I need one."
LETTER TO CARRIE, 22 SEPTEMBER 1917

"I decided to stay out at the Pueblo as it was such a fine day & I started another picture of a young girl standing by a door & a water jar at her feet. I will finish that tomorrow afternoon."
LETTER TO CARRIE, 8 OCTOBER 1917

The Santa Clara pot that Wores purchased on September 21st shows up in several of his Taos paintings – often in the foreground, but sometimes tucked into a corner of the background. It is interesting to note that the price of the Santa Clara jar was equal to the daily wage that Ralph Martinez earned from Wores.

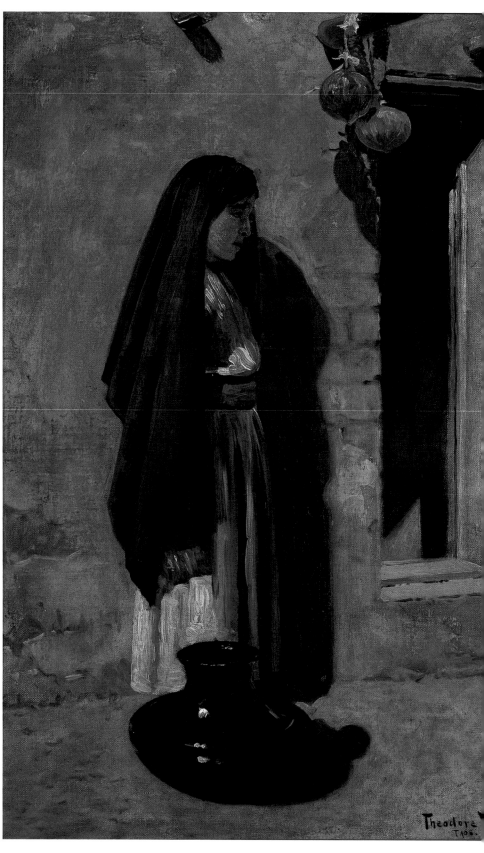

At the Door
1917
Theodore Wores
oil on canvas
History Collections, Natural History Museum
of Los Angeles County

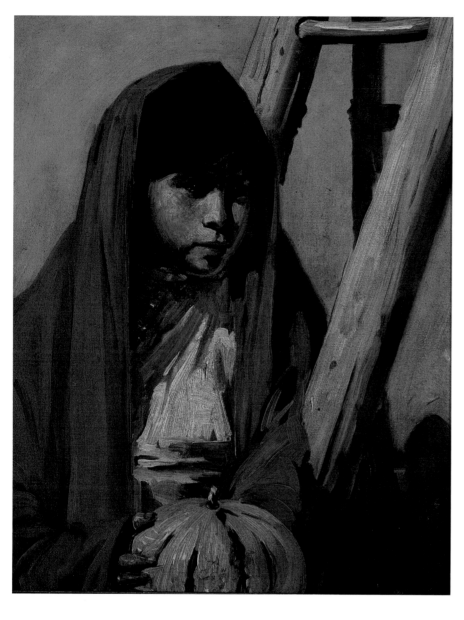

The Red Mantilla, Taos
1917
Theodore Wores
oil on canvas
History Collections, Natural History Museum
of Los Angeles County

*"This morningI painted a
canvas 16 x 20 of a girl in full
sunlight sitting on a ladder with a
pumpkin in her arms as if she had
stopped for a moment as she was
taking it up on the roof to dry. I
think it is all right. It looks sunny."*
LETTER TO CARRIE, 15 OCTOBER 1917

Model for "The Red Mantilla, Taos"
1917

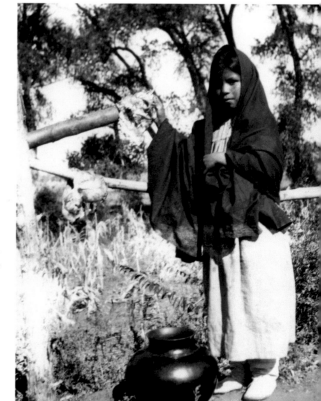

Wores arrived in Taos on September 8, 1917 – a Saturday. By the next day, he already found a local resident of the Taos Pueblo to serve as his guide and interpreter. Wores wrote to Carrie,

"I have made a deal with a young Indian who has a team of two horses to work for me for $1.50 a day. That is I can have him all day. He will pose & get other models for me."
LETTER TO CARRIE, 9 SEPTEMBER 1917

Although Wores knew the young man as Ralph Martinez, throughout his correspondence to Carrie, he referred to Martinez as "my Indian," a phrase that seems to connote Martinez as a stereotype, the "Indian guide," but also perhaps to distinguish him from residents of the Taos Pueblo who were modeling for the other artists in the Taos community. As with Pueblo Indians throughout the Southwest, many had adopted Hispanicized names, while also having a name in their native language as well, a practice often continued to this day. Ralph Martinez' translated Tiwa name was Elk Flying Water. The eldest of six children born to Lorenzo and Marquita Martinez, his only brother, Albert Looking Elk, was also very involved in the arts community in Taos. Albert Looking Elk served as a model and assistant to Taos artist Oscar Berninghaus, who supplied his with a paint set and lessons. Looking Elk became a notable artist in his own right.

Ralph Martinez was primarily a farmer and rancher who raised horses and cattle, and grew corn and other crops. Martinez never married but raised two adopted children, including a son who went by the name "Little Ralph," and who appears in a number Wores' Taos photographs and paintings.

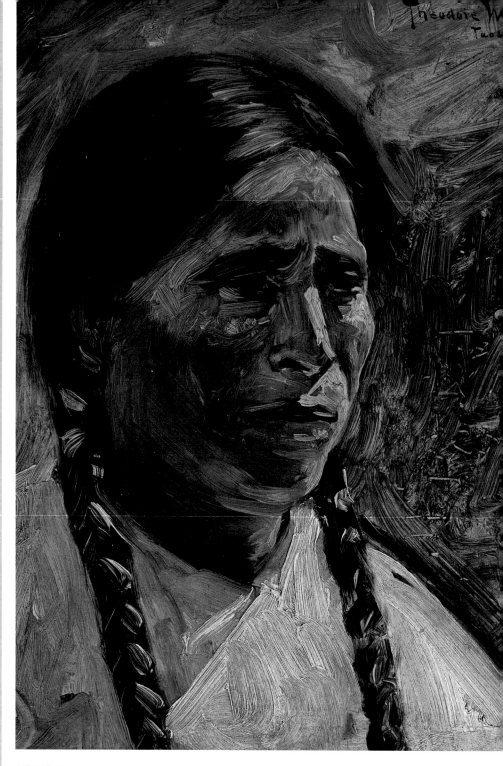

A Taos Type
1917
Theodore Wores
oil on canvas
History Collections, Natural History Museum
of Los Angeles County

"My Indian came but through a misunderstanding he did not bring his rig but came on horseback. He did not understand that I wanted to go to the Indian town [Taos Pueblo]. So I had him pose for me in the garden & painted his head, 9 x 12, so my morning was not wasted."
LETTER TO CARRIE, 10 SEPTEMBER 1917

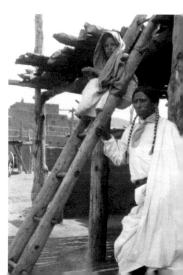

Elk Flying Water "Ralph" Martinez
circa 1920

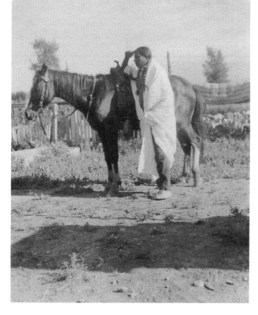

Ralph Martinez posing for "The Scout,"
Taos Pueblo
1917

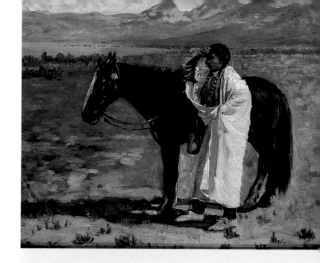

The Scout, Cattle Herder, Taos
1917
Theodore Wores
oil on canvas
History Collections, Natural History Museum
of Los Angeles County

"Tomorrow morning my Indian is coming on horseback with one of those white mantels [sic] & I am going to paint him sitting on his horse leaning forward with his hand up to his eyes, gazing into the distance presumably at an approaching foe."
LETTER TO CARRIE, 11 SEPTEMBER 1917

Although Wores' letter home to his wife, written the evening before he started the painting, clearly states that Wores intended to paint a mounted figure, when Wores actually started painting, he changed the composition. Martinez is no longer mounted, but standing next to his horse. In his letter home to his wife, Wores comments, "It was very hot this morning;" which may explain why the composition was altered.

"Well my Indian turned up about a quarter past eight....I had him standing by the side of his horse wrapped in a white mantle & with his hand shading his eyes looking intently into the distance. It suggests an outpost watching for the enemy. This canvas is 16 x 20 & I have the Indian finished & the horse will be painted tomorrow morning."
LETTER TO CARRIE, 12 SEPTEMBER 1917

"This morning I worked from eight to twelve & finished the Indian picture of "The Scout." I had some misgivings about the horse but it turned out all right & even the Indian expressed his approval & said it was a perfect portrait of his pony."
LETTER TO CARRIE, 13 SEPTEMBER 1917

Ralph Martinez, Theodore Wores, and "Little Ralph"
in Martinez' Rig, Taos, New Mexico
1917

It is curious that Wores posed his model shading his eyes but with the sun at Ralph Martinez' back. In all but one of the photographs that Wores composed to assist him with future compositions or later enhancements to this painting, the sun is behind the model and the shadows before him. This pose was likely inspired by numerous Native American genre paintings Wores would have seen at the time, including "The Scout" by Cyrus Edwin Dallin, a piece featured at the PPIE in 1915.

Similar in composition to "A
Lesson in Archery," which Wores
painted at the PPIE in 1915, this
painting depicts Ralph Martinez
and his adopted son, Little
Ralph. According to Martinez'
nephew, it was a common practice
for relatives to participate in
raising one another's children.
The "adoptions" were casual.
Martinez also adopted and raised
a little girl called Carmel.

The sunflowers in the background
of this painting are likely a
reflection of the artist's lifelong
passion for interpreting flowers
on canvas and not an actual
record of botanical conditions
at the Pueblo. It is doubtful
that sunflowers were in bloom
anywhere near the Taos Pueblo
in September 1917. The neat,
regular brickwork in the
background wall is reminiscent of
the buildings Wores documented
at the PPIE. It does not reflect the
typical building surfaces of the
Taos Pueblo.

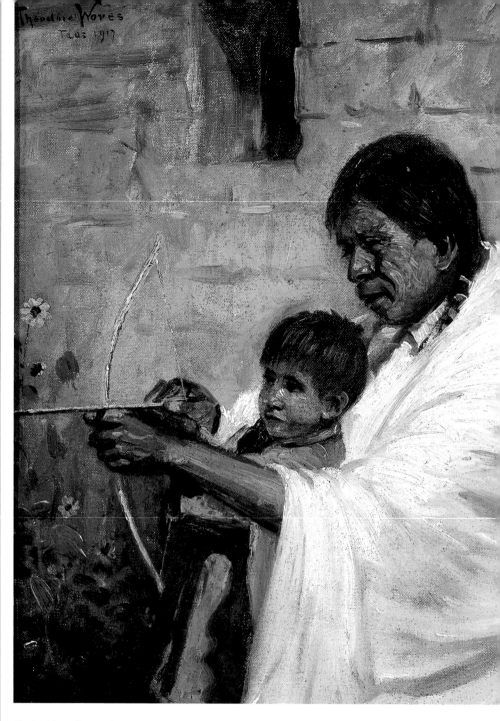

The Making of a Warrior
1917
Theodore Wores
oil on canvas
History Collections, Natural History Museum
of Los Angeles County

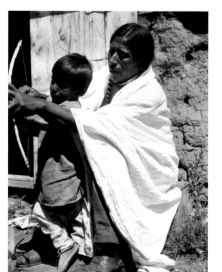

Ralph and "Little Ralph" Martinez posing for
"The Making of a Warrior I"
1917

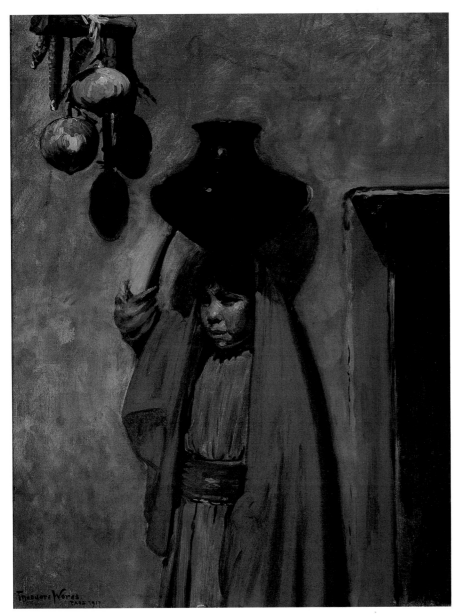

A Water Carrier of Taos
1917
Theodore Wores
oil on canvas
History Collections, Natural History Museum
of Los Angeles County

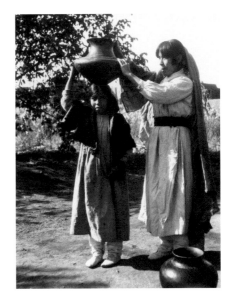

Model for "A Water Carrier of Taos"
1917

"I was out at the Pueblo this morning & started a picture 18 x 24 of a little Indian girl holding a water jar on her head. She has a bright red shawl & stands against an adobe wall in full sunlight. As the water jar was rather heavy I fastened it with a string to a projecting beam & so she only had to stand under it. I just about finished the girl & tomorrow I will paint the jar & the background with yellow corn & red peppers hanging from the adobe walls."
LETTER TO CARRIE, 6 OCTOBER 1917

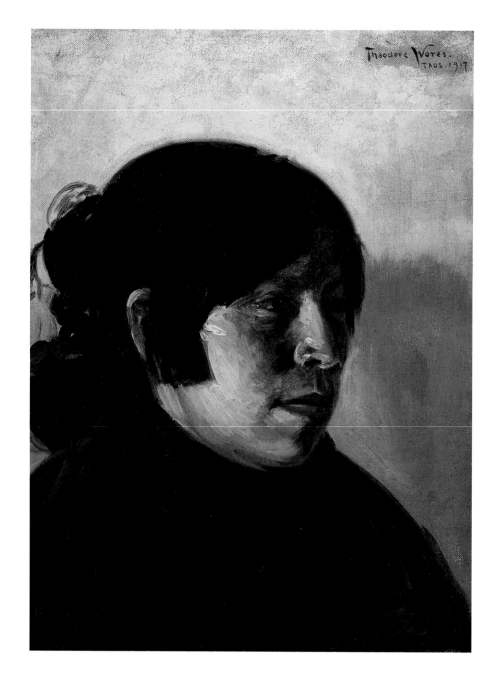

A Woman of Taos
1917
Theodore Wores
oil on canvas
History Collections, Natural History Museum
of Los Angeles County

"After lunch under the trees I returned to the Indian's house & found a very fine type, a young woman who was visiting them. I suggested that she give me a sitting to which she cheerfully consented & I painted a head on a 12 x 16 canvas & it is about the best head I have painted."

LETTER TO CARRIE, 20 SEPTEMBER 1917

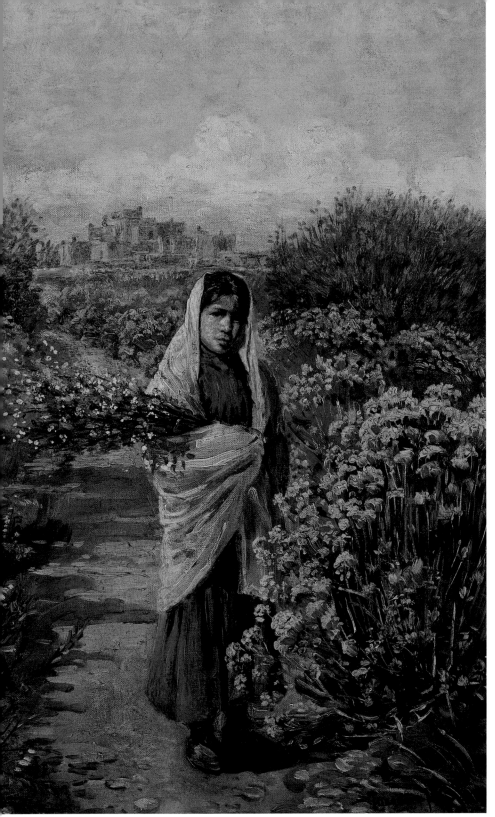

Wild Flowers of Taos, New Mexico
1917
Theodore Wores
oil on canvas
History Collections, Natural History Museum
of Los Angeles County

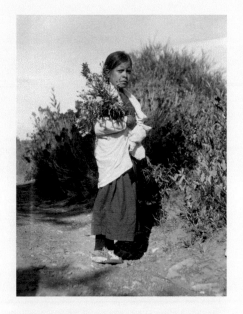

Model for "Wild Flowers of Taos, New Mexico"
1917

"I was out early to the Pueblo & my Indian had a pretty little girl model for me. We took her in the team & went just out of the town where the wild flowers are abundant & I posed her with a bunch of wild flowers in her arms & half hidden by the masses of yellow sage blossoms which are higher than her head. Then there are masses of Indian paint brush three or four feet high & in the distance the Pueblo of Taos looms up very interestingly. She is posed in full sunlight, the canvas is 16 x 24 & I have finished the figure & Monday morning I will finish the rest."
LETTER TO CARRIE, 22 SEPTEMBER 1917

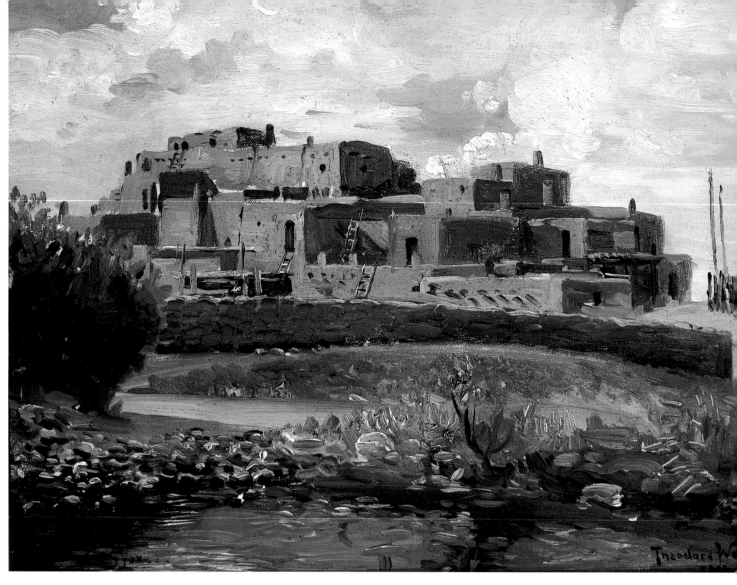

The Pueblo of Taos
1917
Theodore Wores
oil on canvas
History Collections, Natural History Museum of
Los Angeles County

"This afternoon I painted a sketch
of the Pueblo, 12 x 16, & I did not
get back until five o'clock."
LETTER TO CARRIE, 22 SEPTEMBER 1917

"Two young Indian boys have been tagging after
me when I go to paint. Perhaps the attraction lies
in the fact that I always eat my lunch by the stream
under the trees & as Mrs. Leatherman always packs
more lunch than I can eat, I give the remnants to
my Indian friends. This noon they were there as
usual & one of them offered me three small trout
that he had caught. They are very amusing & help
to wile [sic] away the noon hour."
LETTER TO CARRIE, 22 SEPTEMBER 1917

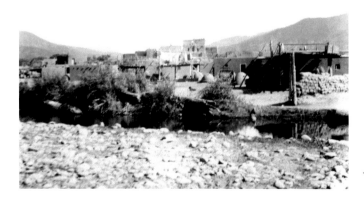

The Pueblo of Taos
1917

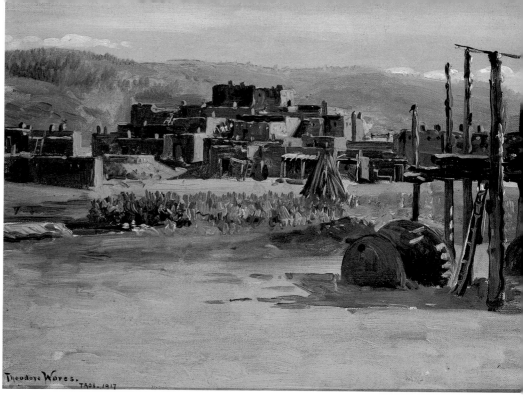

Morning in Taos, New Mexico
1917
Theodore Wores
oil on canvas
History Collections, Natural History Museum of Los Angeles County

"This afternoon I painted another view of the Pueblo, 12 x 16,
& finished it & left for home at 4 o'clock."
LETTER TO CARRIE, 3 OCTOBER 1917

Taos Pueblo scene
1917

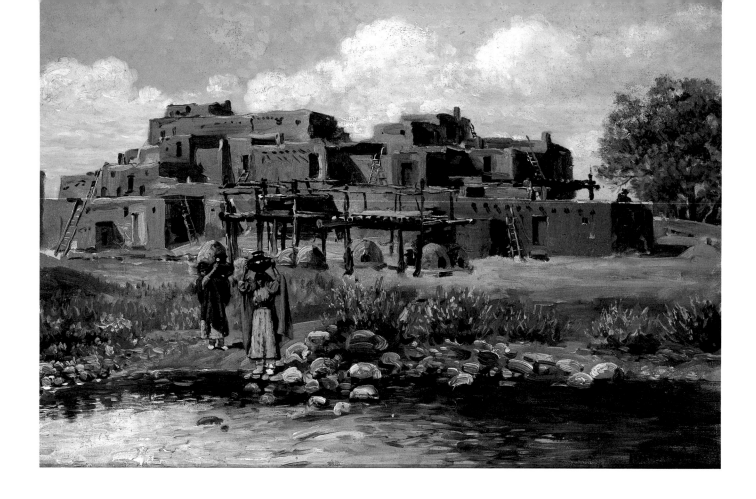

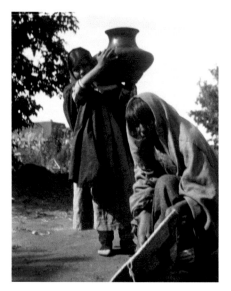

Models for "The Pueblo of Taos I"
1917

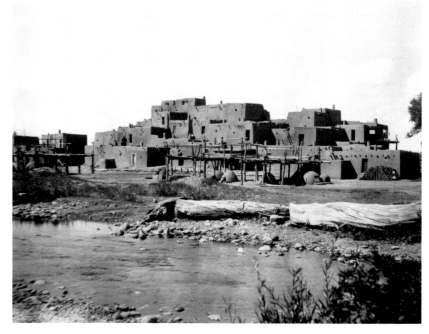

The photographic study for "The Pueblo of Taos I"
1917

"I took eight photographs of a couple of nice looking young Indian girls. I posed them with water jars on their shoulders & heads & they should make attractive pictures & [be] useful in finishing some of the Pueblo views I painted here."

LETTER TO CARRIE, 21 SEPTEMBER 1917

The Pueblo of Taos
1917
Theodore Wores
oil on canvas
History Collections, Natural History Museum of Los Angeles County

"My Indian called for me early this morning & I took lunch along & worked out at the Pueblo all day. I finished the picture of the Indian girl [The Painted Jar] in the morning & started a 16 x 24 canvas of the Pueblo. I got a good start but a terrific gale started up & it was impossible to continue. However I will go out again tomorrow & finish this picture & paint another in the morning."
LETTER TO CARRIE, 17 SEPTEMBER 1917

This landscape shows the portion of the Taos Pueblo that is on the north side of the river. The figures of the two young girls were inserted into the painting later. While in Taos, Wores took dozens of photographs of the scenery and the people. He would send the rolls of exposed film back to his wife, Carrie, in San Francisco to be developed. During the early part of his stay, Carrie would then send the developed film and the prints back to Wores in Taos.

Like many artists of the late 19th and early 20th century, Wores used photography extensively to assist him in composing his paintings. Wores took great pride in being a student of Frank Duveneck, in filling his canvases directly with paint without first sketching the scene, and in painting "in the moment" and out-of-doors. Photography allowed Wores to capture the moment on film, so that it could be captured later on canvas. However, Wores did not use photography to spare his models. His Taos correspondence frequently makes reference to his models "panting" in the heat or "turning green." However, Wores worked under the same conditions as his models.

"I have succeeded in getting a fine case of sunburn & my nose is all peeling off. Rolshofen [sic] and Philipps [sic] both remarked this afternoon that I was a sight. By the time I join you I think I will be presentable again."
LETTER TO CARRIE, 25 SEPTEMBER 1917

"This out-of-doors painting has made a sight of me. My nose is peeling and the skin is all coming off my hands. So don't mistake me for an Indian when I get off the train..."
LETTER TO CARRIE, 4 OCTOBER 1917

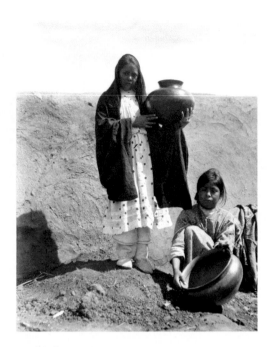

Models for "At the River in Taos"
1917

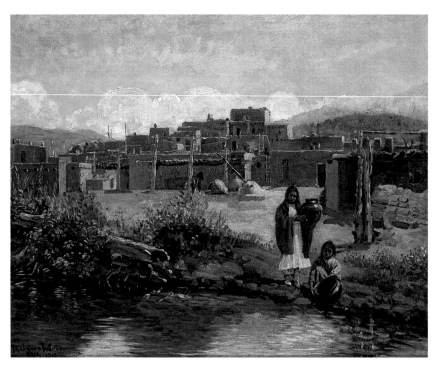

At the River in Taos
1917
Theodore Wores
oil on canvas
History Collections, Natural History Museum of
Los Angeles County

"This morning I was out early with my Indian & started a new view of the Pueblo, 16 x 20, with a very attractive foreground of stream & foliage. It was a fine sunny day & I got in a good morning's work & will finish tomorrow."

LETTER TO CARRIE, 20 SEPTEMBER 1917

"I was out at the Pueblo early this morning & finished the picture that I started yesterday & it is one of the best – miles ahead of those views I painted in S.F."

LETTER TO CARRIE, 21 SEPTEMBER 1917

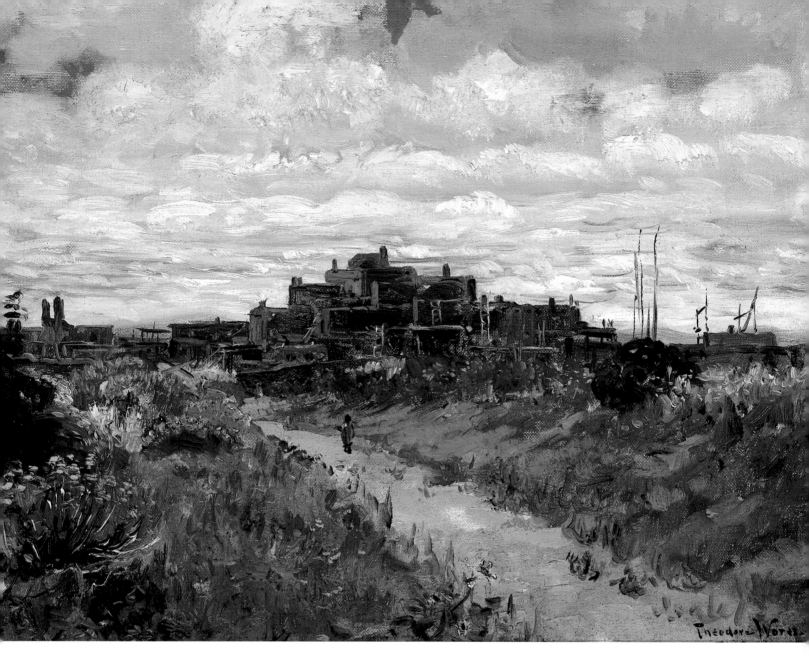

Distant View of Taos
1917
Theodore Wores
oil on canvas
History Collections, Natural History Museum of Los Angeles County

"I painted a view of Taos from just outside of the wall 12 x 16 & it turned out pretty good."
LETTER TO CARRIE, 11 SEPTEMBER 1917

*"I was very much amused this morning at breakfast when Mrs. Leatherman said that she thought
the picture I painted of Taos the other day was the best she had ever seen. She said she had seen
a great many but this pleased her better than any. How was that for a compliment?"*
LETTER TO CARRIE, 13 SEPTEMBER 1917

This landscape is the second painting that Wores executed while in Taos. He says he painted it
"from just outside of the wall" of the Pueblo. The viewpoint is from the east side of the Pueblo,
along the ceremonial raceway – an area that is now off limits to outsiders.

Although Wores prided himself on capturing the exotic and picturesque, and subsequent art historians have attributed to him the skills of an early cultural anthropologist, in this instance Wores misidentified his subject matter. The "horno" style ovens in the foreground are for baking bread and not for firing pottery – a common mistake made by tourists then, and tourists now. Unlike his time in Japan, where Wores spent 32 months on his first visit and fifteen months on his second, Wores spent only six weeks in Taos. In Japan, Wores lived with the son of a high government official, circumventing the statutes requiring foreigners to live in restricted areas of the city and offering him extensive insights into the local culture. Separated from the influence of other foreigners like himself, and with youthful enthusiasm, the artist immersed himself in Japanese culture, and didn't even begin painting until he had been in Japan for several months.

Such was not the case in the Southwest. In Taos, Wores boarded with a local Anglo family and he spent his leisure time socializing with the Taos artists and their patrons. Although he often spent his days with Ralph Martinez at the Pueblo, his extremely short visit, by intention or not, provided him little of the same amount of attention to ethnographic detail and exposure to indigenous culture as he had experienced in Japan.

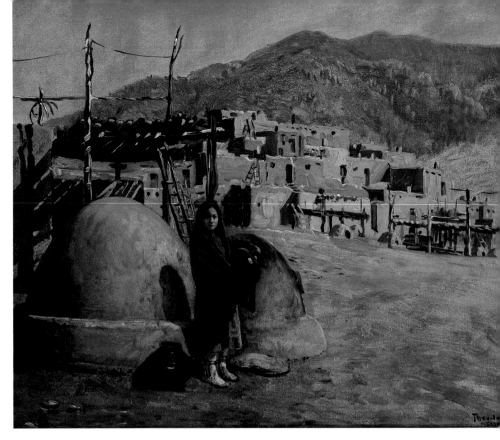

A Bake Oven for Pottery
1917
Theodore Wores
oil on canvas
History Collections, Natural History Museum
of Los Angeles County

"My Indian was an hour early this morning & I was at the Pueblo shortly after 8 o'clock. I selected a fine subject, a view of the main buildings five stories high & the mountains in the background. In the foreground are a couple of those round ovens & it will make a very attractive picture, 16 x 20. When I started the sky was blue & not a cloud in sight, & it continued fine until about 11 o'clock when dark clouds came over the mountains & sounds of distant thunder. By this time I had painted in the most important part of the picture so I packed up & made tracks for my Indian's house & then the storm broke loose."
LETTER TO CARRIE, 18 SEPTEMBER 1917

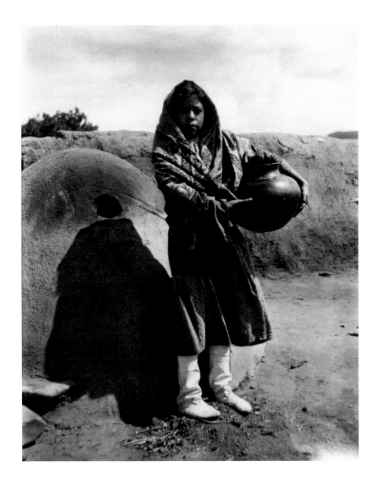

Model for "A Bake Oven for Pottery"
1917

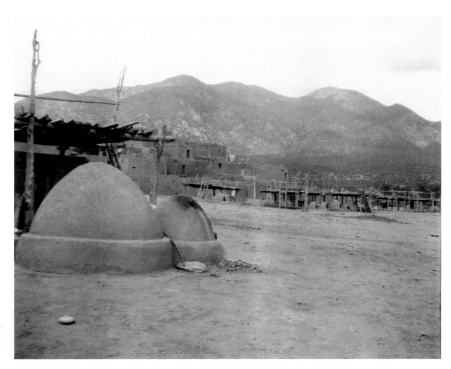

The photographic study for
"A Bake Oven for Pottery I"
1917

Model for "Gathering Wild Plums, Taos I"
1917

According to Wores' letters, Ralph Martinez' younger sisters posed for "Gathering Wild Plums." The artist took dozens of photographs of these two models, as well as other young women, at this location. All the models were probably Martinez' sisters and cousins. In this photo, the artist's easel can be seen behind the younger model.

One morning when Wores was working at the Pueblo, he decided to return to the town of Taos earlier than his guide, Ralph Martinez, anticipated. Martinez was occupied, so he delegated his younger sisters to drive the artist back to town. Wores recounted the trip in his nightly letter to Carrie:

"As I felt rather tired I decided to return to town early in the afternoon. I found that my Indian was so busy hauling in his grain from the field that he could not quit so early, so he told me he would have his sisters drive me back to town. So we started, the three of us and it was a very amusing trip....These girls seemed to have but one idea of driving horses and that was to beat them uninterruptedly. When one was tired the other took the whip. I said to the younger one (who is unmarried) -- after she had given the horses a good whack with the whip -- "My but I am sorry for the husband that you will have one of these days." From the Indian point of view, this must have been a huge joke for they laughed immediately over it, and then burst out laughing every once in a while."
LETTER TO CARRIE, 22 SEPTEMBER 1917

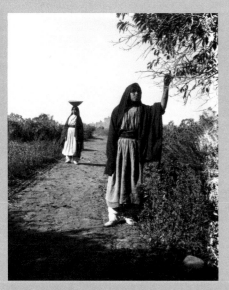

Models for "Gathering Wild Plums, Taos II"
1917

Gathering Wild Plums, Taos
1917
Theodore Wores
oil on canvas
History Collections, Natural History
Museum of Los Angeles County

Younger Model for "Gathering Wild Plums,
Taos I"
1917

"My Indian's father came in for me this morning & I found my models waiting & I made an early start. We go just outside of the Pueblo where there are a lot of wild [plum] trees loaded down with bright red fruit. The sister of my Indian is a good & pleasing type & I succeeded in getting a good start. She is standing in the path reaching up for the plums & the little girl is facing her holding a basket for the fruit. The little girl is a perfect little beauty, large black eyes & a pretty face. I took a half a dozen photographs of her during the rests & I will use her for other pictures."
LETTER TO CARRIE, 25 SEPTEMBER 1917

"I was out at the Pueblo & painting by 8.30 so I got in a good morning's work. It was a beautiful day, not hot & not a cloud in the sky. I had the little girl pose for the plum picking picture & succeeded in finishing her. Tomorrow the other girl will pose for about an hour & then she will be finished. I will spend the rest of the morning painting in the plum tree & the background with the pueblo in the distance."
LETTER TO CARRIE, 27 SEPTEMBER 1917

"I was out early this morning at work on my picture – "Wild Plums" & succeeded in getting in all the balance of the background. On the way out my Indian got out of the rig at a place where there were a lot of wild plums & cut off a branch loaded down with ripe red plums. We took it out to where I was painting & stuck it into the tree that is in the picture & it made a much better effect when I painted it in."
LETTER TO CARRIE, 29 SEPTEMBER 1917

A Little Maid of Taos
1917
Theodore Wores
oil on canvas
History Collections, Natural History Museum of Los Angeles County

"After I had my lunch by the stream under the trees, I went to the Indian's house & painted a head of the little girl, 12 x 16, who is to be in the plum picture. It turned out all right and makes a pretty & attractive picture. I have taken about a dozen photographs of this little girl in all kinds of poses & they will come in very useful later on."
LETTER TO CARRIE, 26 SEPTEMBER 1917

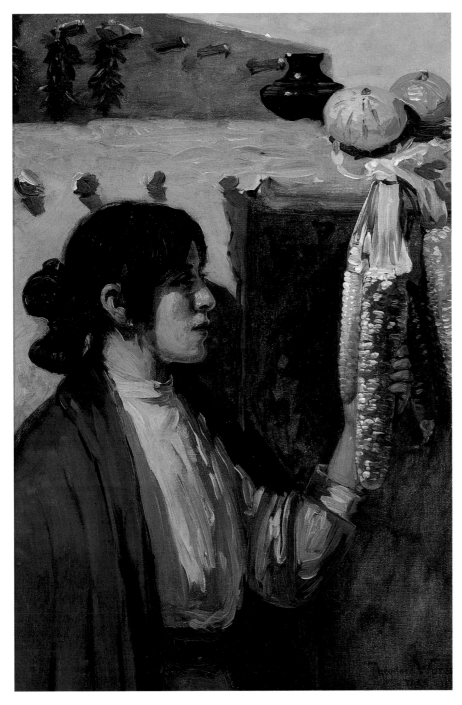

Model for "Harvest Offering"
1917

Harvest Offering
1917
Theodore Wores
oil on canvas
History Collections, Natural History Museum
of Los Angeles County

*"I was out at the Pueblo early this morning & started and finished
a picture of an Indian girl hanging up a bunch of Indian corn, size
16 x 24, & I think it is one of my best."*
LETTER TO CARRIE, 13 OCTOBER 1917

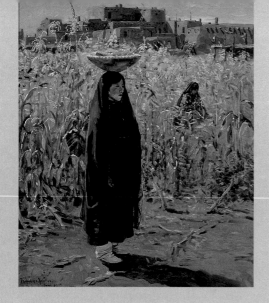

Corn Harvest, Taos
1917
Theodore Wores
oil on canvas
History Collections, Natural History Museum
of Los Angeles County

"Well I got to work early this morning. Started a picture, 25 x 30, of an Indian woman with a basket filled with corn in a corn field on the other side of the wall of the Pueblo. She has a blue shawl over her head & a red skirt so that it makes quite a colorful effect. The yellow cornfield makes a good background & the Pueblo looms up back of the cornfield. I got a good start & tomorrow morning I will finish the figure."

LETTER TO CARRIE, 21 OCTOBER 1917

"I returned to the town a little after two o'clock & brought the picture of the cornfield....with me & when I saw it in a good light in my room, I was convinced that this will be regarded as the best of all my Indian pictures. That one picture only would have made this trip worthwhile..."

LETTER TO CARRIE, 5 OCTOBER 1917

"Mr. Philips [sic], one of the artists who lives here came in about 4-30 & has just left. He came to see my work & was very well pleased with it. His favorite was the girl in the cornfield. He thought it was wonderful how much I had accomplished in the time that I was here, and said I had gone about it in the right way. I was very glad of his approval for he is one of the more conservative artists & does not look at them from the view of an extremist."

LETTER TO CARRIE, 11 OCTOBER 1917

The woman in this painting is probably one of Ralph Martinez' sisters. She may also be the model in "The Painted Jar."

On a Thursday afternoon, shortly before he left Taos, Wores invited artist Bert Phillips to come by his room at the Leathermans' boarding house and see his recent work. Phillips and Wores were united in their view of "modernist" art. As Wores writes in his letter to Carrie, Phillips was one of the more conservative of the Taos artists.

Like Wores, Phillips studied art in Europe. While a student in Paris, he first met fellow artists and future members of the Taos Society of Artists, Ernest Blumenschein and Joseph Sharp. And, also like Wores, Phillips was not impressed with the modern art movement. Phillips felt that it devalued his paintings to have them exhibited along side the work of "modernist artists" whom he considered to be amateurish.

Towards the end of his career, Wores became embroiled in a contentious battle between "modernist" artists and representational artists being waged in the Bay area and more specifically at the Bohemian Club. In the end, Wores removed himself from San Francisco and settled in Saratoga, California, a small community located in the foothills of the Santa Clara Valley about 50 miles south of the city. In a 1927 interview in the San Francisco *Chronicle*, Wores explained his move to Saratoga saying, "I can breathe the wholesome mountain air unpolluted by poisonous germs of diseased art."

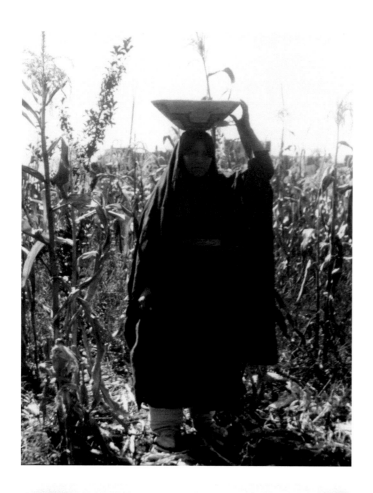

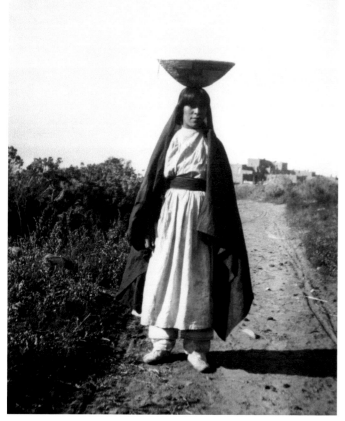

Two photographs of woman posing for
"Corn Harvest," Taos
1917

As with the black Santa Clara jar that Wores purchased at one of the local shops, the Apache basket in this photograph shows up in several of Wores' Taos paintings and photographs. One wonders if Wores also purchased this basket to use as a prop. There were a number of shops selling to the tourists visiting Taos. One of the most prominent of the merchants was Ralph Meyers, an artist, photographer and trader who ran a curio shop specializing in Indian artifacts. Meyers exhibited at the Santa Fe Museum and with the Taos Society of Artists, but he was never invited to join the group. Wores mentions visiting Meyers' studio in his letters home to Carrie.

"I went to my Indian's house & found it was a nice clean place. I discovered he had a sister who is a fine type of the Taos woman. She was dressed in a very attractive costume & I decided to paint her then & there. The light was good & I posed her standing against the white washed wall with a water jar in her arms. I painted on a 16 x 24 canvas & the head is about the length of this sheet of paper. I succeeded in finishing the head by about 5.30 o'clock & returned to town. I think this head is one of the best I have painted & if the rest turns out as well it will be one of my best pictures. It will require two afternoons more."

LETTER TO CARRIE, 16 OCTOBER 1917

"In the afternoon I painted in my Indian's house on the picture I started last week of his sister with the water jar. I was not quite satisfied with the pose of the hands so I changed it & it is a whole lot better."

LETTER TO CARRIE, 24 OCTOBER 1917

Ralph Martinez had four sisters, Yellow Locust Tree, Emily, Juliana and Josephine. The young woman in this painting is probably the oldest of the sisters, Yellow Locust Tree.

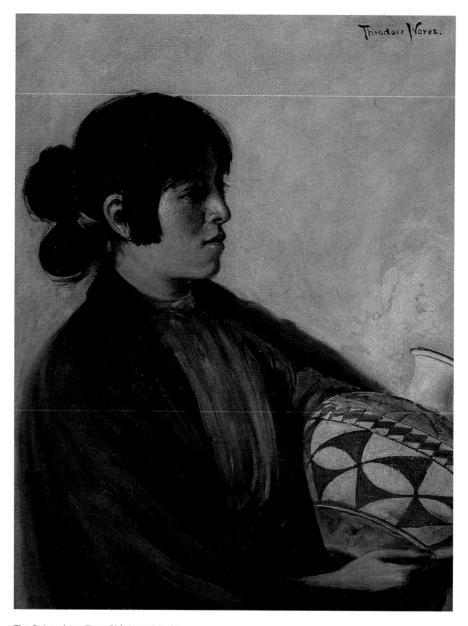

The Painted Jar, Taos Girl, New Mexico
1917
Theodore Wores
oil on canvas
History Collections, Natural History Museum
of Los Angeles County

"I was out at the Pueblo as usual this morning. I had asked my Indian (whose name by the way is Ralph Martinez) to get a model for me, a cousin & a rather fine looking girl. I intended to paint a head but I found them all at work storing pumpkins in a shed so I could not resist the temptation of painting this girl over half length....with a pile of pumpkins & she is holding one in her hands. It makes a bright colored picture with a red shawl over her shoulders, size 18 x 24. I made up my mind that the picture must be finished in one sitting. So I did all I could in the morning & had her come again after one o'clock and by 2-30 I had it about completed. The hand is not quite.... satisfactory but I can fix that up later in New York."
LETTER TO CARRIE, 12 OCTOBER 1917

The model in this painting may be Ralph Martinez' cousin, Elk Grass.

Storing Pumpkins, Taos, New Mexico
1917
Theodore Wores
oil on canvas
History Collections, Natural History Museum
of Los Angeles County

This is the only one of Wores' Taos paintings that is not described in his letters home to Carrie. Since Carrie was leaving San Francisco to meet Wores at the train station in Lamy, New Mexico and then continue on to New York with him, Wores stopped writing to Carrie after October 15th. It is likely that this portrait was painted in those waning autumn days in Taos. In a letter to Carrie on October 10th, Wores writes:

"The few remaining days I have here I will devote to painting characteristic heads & about next Tuesday (October 16th) I will quit painting."
LETTER TO CARRIE, 10 OCTOBER 1917

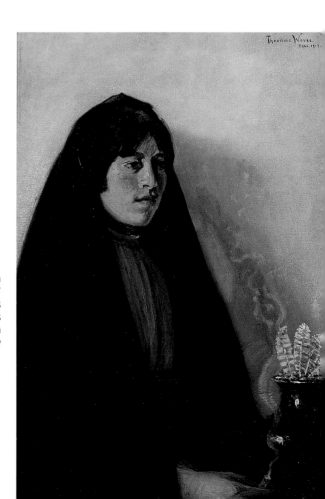

Incantation
1917
Theodore Wores
oil on canvas
History Collections, Natural History Museum
of Los Angeles County

Photograph of women posing for
"Winnowing Beans," Taos
1917

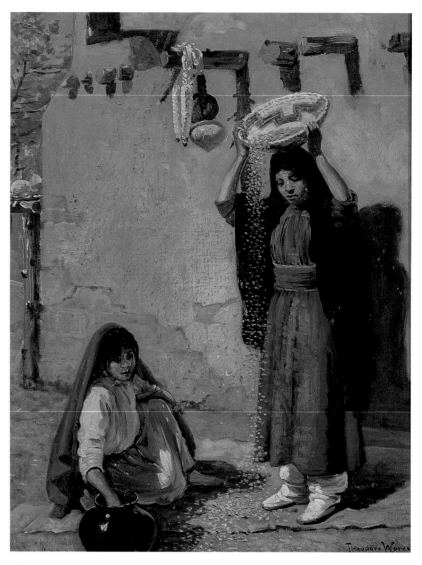

Winnowing Beans, Taos, New Mexico
1917
Theodore Wores
oil on canvas
History Collections, Natural History Museum of Los Angeles County

*"I was out at the Pueblo early this morning & worked on the picture
of the girl with the basket on her head cleaning beans. I finished the
figure & painted in a lot of the background. Tomorrow I will paint in
the other figure seated on the ground & putting the beans in an
Indian jar.*

*"While I was painting on this picture along comes a man with his
camera. He said his name was Clatworthy from Colorado & he was
taking colored photographs for his lectures. He asked me if I would let
him take a picture of me standing before my picture as if painting
I consented & he took the picture. He said he would be giving lectures
in New York next winter & would drop me a line at the Century Club &
let me know when it will take place. It will be amusing for us to go &
see this picture on the screen, will it not?"*

LETTER FROM THEODORE WORES TO HIS WIFE, CARRIE BAUER WORES,
10 OCTOBER 1917

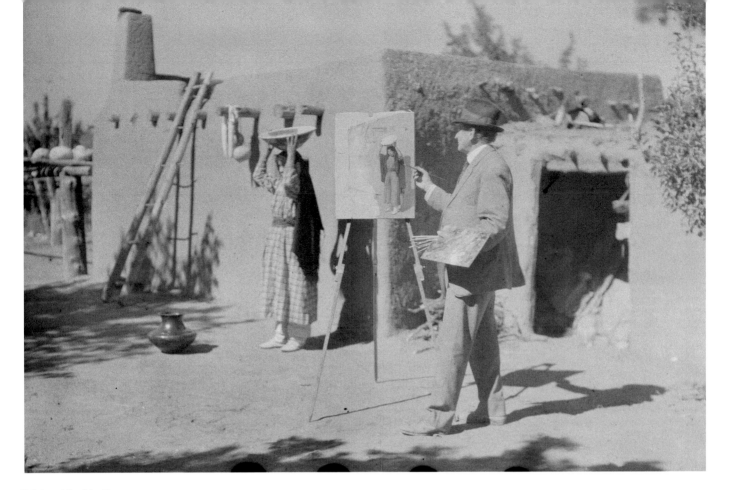

Painter at Pueblo, Taos
October 10, 1917
Fred Payne Clatworthy, photographer (1875-1953)
Lumiere Autochrome on glass, 5" x 7"
Courtesy Colorado Historical Society, (10031218)

On the morning of October 10, 1917, Colorado photographer Fred Payne Clatworthy may have found a kindred spirit in Theodore Wores when he encountered the painter at work at the Taos Pueblo and asked permission to take his photograph. Clatworthy was en route home to Estes Park, Colorado after a three-week photo shoot at Mesa Verde National Park. Like Wores, Clatworthy traveled widely, documenting exotic locales such as Mexico, New Zealand, Tahiti and Hawaii.

But Clatworthy's first love was Colorado's Rocky Mountains. He is known for his autochromes and hand-tinted photographs of the American West. Clatworthy sold his scenic color photos out of his Estes Park studio to tourists visiting Rocky Mountain National Park. He also worked on photo assignments for National Geographic magazine, Matson Navigation Company, and the western railroads.

To reach a larger audience, Clatworthy developed lecture tours illustrated with his autochromes, employing a custom-made lantern projector and a twelve-foot screen. Clatworthy's winter 1918 lecture program included his most recent images of "Cliffdweller Ruins." That winter, his lecture tour took him to Chicago, Boston, and Columbia University in New York.

Did Clatworthy include this photograph of Wores in the 1918 lecture series? Did Wores and his wife attend the lecture at Columbia University while in New York during the winter of 1918? We have no evidence one way or the other – only the intriguing possibility mentioned in a letter the artist wrote home to his wife.

Acknowledgements

The editor especially thanks project researcher Paula Rivera and her grandfather, Mr. Lorenzo Alfred Lujan, of Taos Pueblo. Their enthusiasm and energy for the project brought life back to Wores' Taos works, putting names and personalities to the people in the paintings.

Joining the editor, exhibition curator Pamela Young Lee, and Ms. Rivera for our project kick-off seminar in Taos were: Marsha Bol, PH.D., art historian and director of the Museum of New Mexico's Fine Arts Museum in Santa Fe; Jennifer Liss, former publications director for the California Historical Society; Tessie Naranjo, Ph.D., independent scholar and author from Santa Clara Pueblo; David Turner, former director of the Fine Arts Museum in Santa Fe and now director of the Schnitzer Museum of Art at the University of Oregon; Malcolm Margolin, publisher, Heyday Books, and everyone's favorite guru; Karen Lichtenberg, former assistant publisher, Heyday Books; Tony Abeyta, renowned Native American artist; Gilbert and Martha Suazo, Taos Pueblo elders and artists; Elizabeth Cunningham, independent art historian, author and authority on the Taos Art Society; and Judith Goldberg and Doug Crawford, videographers, who carefully recorded our seminar for later reference. Tremendous thanks go to all the seminar participants whose comments and insights helped us develop this project.

The California Historical Society also acknowledges the assistance of dozens of staff, volunteers and independent researchers at numerous cultural institutions in the Southwest for their dedicated efforts in preserving and sharing the resources that have made this exhibition and catalog possible. Among them, CHS intern, Christie Anderson, who conducted research on the PPIE under Pamela Young Lee's direction at the San Francisco Public Library and the Bancroft Library, and discovered numerous photographic images that demonstrated dozens of Wores' Southwestern paintings depicted scenes of the PPIE and not of Arizona or New Mexico. We are grateful to the staff of the Colorado Historical Society, including Barbara Dey and Michael Wren, for helping us locate the Clatworthy autochrome showing Wores painting at the Pueblo.

Numerous archivists and librarians facilitated research into the primary resources under their care, including Senior Archivist Brian P. Graney

of the New Mexico State Records Center and Archives; Jan Kathy Davis of Special Collections at the University Library of the University of Arizona; Patricia Akre of the San Francisco History Center at the San Francisco Public Library; Coleen Hyde and Michael Quinn at Grand Canyon National Park; Maryellen Fleming-Hoffman, Gallery Manager at Hopi House and the desk staff at El Tovar Resort for Zanterra Parks & Resorts at the Grand Canyon; Thomas Ratz; Rosie D. Skiles; Lisa Itagaki and Kaleigh Komatsu of the Japanese American National Museum; Joseph Traugott, Curator of 20th Century Art at the Museum of Fine Arts in Santa Fe; Tricia Loscher, Exhibit and Program Director at the Heard Museum North; Scott Van Keuren, Assistant Curator of Anthropology at the Natural History Museum of Los Angeles County; and Steven Karr, former Assistant Curator of History at the Natural History Museum of Los Angeles County and currently curator of the Southwest Museum of the American Indian at the Autry National Center.

We are also indebted to Janet Fireman, former Curator of History at the Natural History Museum of Los Angeles County, who enthusiastically assisted in arranging for the loan of the Wores paintings to the Society, and endorsed all our efforts. Thanks also go to Lisa Escovedo, Collections Manager at that institution, who helped enormously at every turn. Conservators Chris Stavroudis and Carolyn Tallent brought the paintings back to their original glory, a job much tougher than originally expected due to aging varnishes apparently applied by Wores when they were first created. Thanks too to everyone at the California Historical Society, including Philip Adam, Photographer and especially Maren Jones, Director of Collections and Exhibitions.

Finally, the author wishes to thank Beverly Becker, who voluntarily edited the manuscript. With you and my little ukulele by my side, everything is perfect.

Sources

Baca, Elmo. *Mabel's Santa Fe and Taos: Bohemian Legends (1900-1950)*, Gibbs Smith, 2000

Baird, Jr., Joseph Armstrong. *Theodore Wores and the Beginnings of Internationalism in Northern California Painting: 1874-1915*, Library Associates, University of California at Davis, 1978

Baird, Jr., Joseph Armstrong. *The Art of Theodore Wores: Japan's Beauty Comes Home*, The Asahi Shimbum, 1986

Benedict, Burton. *The Anthropology of World's Fairs: San Francisco's Panama Pacific International Exhibition of 1915*, Lowie Museum of Anthropology/Scholar Press, 1983

Berke, Arnold. *Mary Colter: Architect of the Southwest*, Princeton Architectural Press, 2002

Bernstein, Bruce. *The Marketing of Culture: Pottery and Santa Fe's Indian Market*, Ph.D. dissertation, University of New Mexico, 1993

Bokovoy, Matthew F.. *The San Diego World's Fairs and Southwestern Memory*, 1880-1940, University of New Mexico Press, 2005

Campbell, Elizabeth with Teresa Hayes Ebie and Dean A. Porter. *Taos Artists and Their Patrons, 1989-1950*, Snite Museum of Art, University of Notre Dame, 1999

Coke, Van Deren. *The Painter and The Photograph*, University of New Mexico Press, 1964

Ewald, Donna and Peter Clute. *San Francisco Invites the World: The Panama Pacific International Exposition of 1915*, Chronicle Books, 1991

Ferbaché, Lewis. *Theodore Wores: Artist in Search of the Picturesque*, private print, 1968

Goetzmann, William H. and Joseph C. Porter. *The West as Romantic Horizon*, Joslyn Art Museum, 1981

Grattan, Virginia L. *Mary Colter: Builder Upon The Red Earth*, Grand Canyon Natural History Association, 1992

Hjalmarson, Birgitta. *Artful Players: Artistic Life in Early San Francisco*, Balcony Press, 1999

Hoffenberg, Peter H.. *An Empire on Display: English, Indian and Australian Exhibitions from the Crystal Palace to the Great War*, University of California Press, 2001

Luhan, Mabel Dodge. *Edge of Taos Desert*, University of New Mexico Press, 1987

Neubert, George W. *Theodore Wores: The Japanese Years*, The Oakland Museum, 1976

Neuhaus, Eugen. *The Art of the Exposition*, Paul Elder and Company, 1915

Norris, Scott. *Discovered Country: Tourism and Survival in the American Southwest*, Stone Ladder Press, 1994

Pardue, Diana F. and Kathleen L. Howard. *Inventing the Southwest: The Fred Harvey Company and Native American Art*, Northland Publishing, 1996

Poling-Kempes, Leslie. *The Harvey Girls: Women Who Opened The West*, Paragon House, 1989

Reynolds, Gary A. "A San Francisco Painter," *American Art Review*, September, 1976

Scott, Amy. *The Taos Society of Artists: Masters & Masterworks*, Gerald Peters Gallery, 1998

Thompson, Jan N. "Theodore Wores," *Art of California Magazine*, May, 1990

Wilson, Chris. T*he Myth of Santa Fe: Creating a Modern Regional Tradition*, University of New Mexico Press, 1997

Wunderlich, Rudolf G. *Theodore Wores, 1858-1939: A Retrospective Exhibition*, Kennedy Galleries, 1973

Wunderlich, Rudolf G. Theodore Wores, 1858-1939, Wunderlich & Company, 1987

A NOTE ON THE TYPE

The essays in this book are set in Goudy Oldstyle, designed by Frederic William Goudy in 1915. Over the course of 50 years, the charismatic and enterprising Frederic W. Goudy designed more than 100 typefaces; he was the American master of type design in the first half of the twentieth century. Goudy Old Style, designed for American Type Founders in 1915-1916, is the best known of his designs.